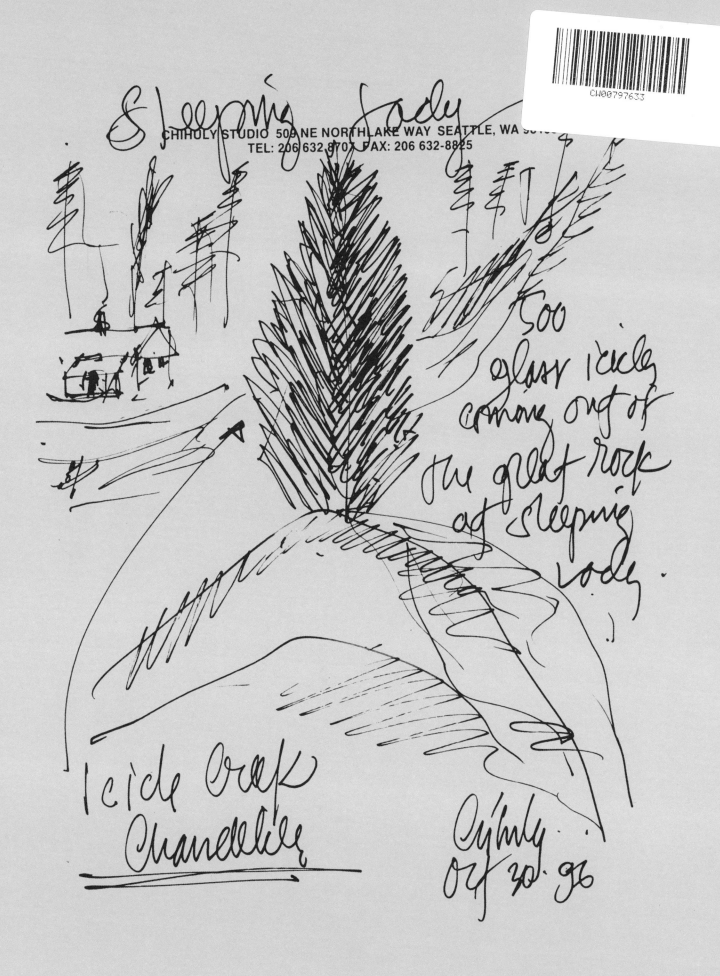

# CHIHULY
## AT KEW

### REFLECTIONS ON NATURE

Kew Publishing
Royal Botanic Gardens, Kew

First published in 2019 by
Royal Botanic Gardens, Kew,
Richmond, Surrey TW9 3AB, UK
www.kew.org

ISBN
Hardback 978-1-84246-682-7
Paperback 978-1-84246-683-4

Distributed on behalf of the Royal Botanic Gardens, Kew in North America by the University of Chicago Press,
1427 East 60th Street, Chicago, IL 60637, USA.

British Library Cataloguing in Publication Data
A catalogue record for this book is available from the British Library.

Design and layout: Jeff Eden
Production: Georgina Hills
Copy-editing and proofreading: Michelle Payne, Gina Fullerlove, Lydia White

For information or to purchase all Kew titles please visit shop.kew.org/kewbooksonline or email publishing@kew.org

Chihuly: Reflections on nature at Kew Gardens,
13 April to 27 October 2019, supported by

Kew's mission is to be the global resource in plant and fungal knowledge and the world's leading botanic garden.

Kew receives approximately one third of its funding from Government through the Department for Environment,
Food and Rural Affairs (Defra). All other funding needed to support Kew's vital work comes from members,
foundations, donors and commercial activities, including book sales.

Printed in Britain by Gomer Press (an ISO 14001 Environmental Management System
and FSC accredited company).

# Contents

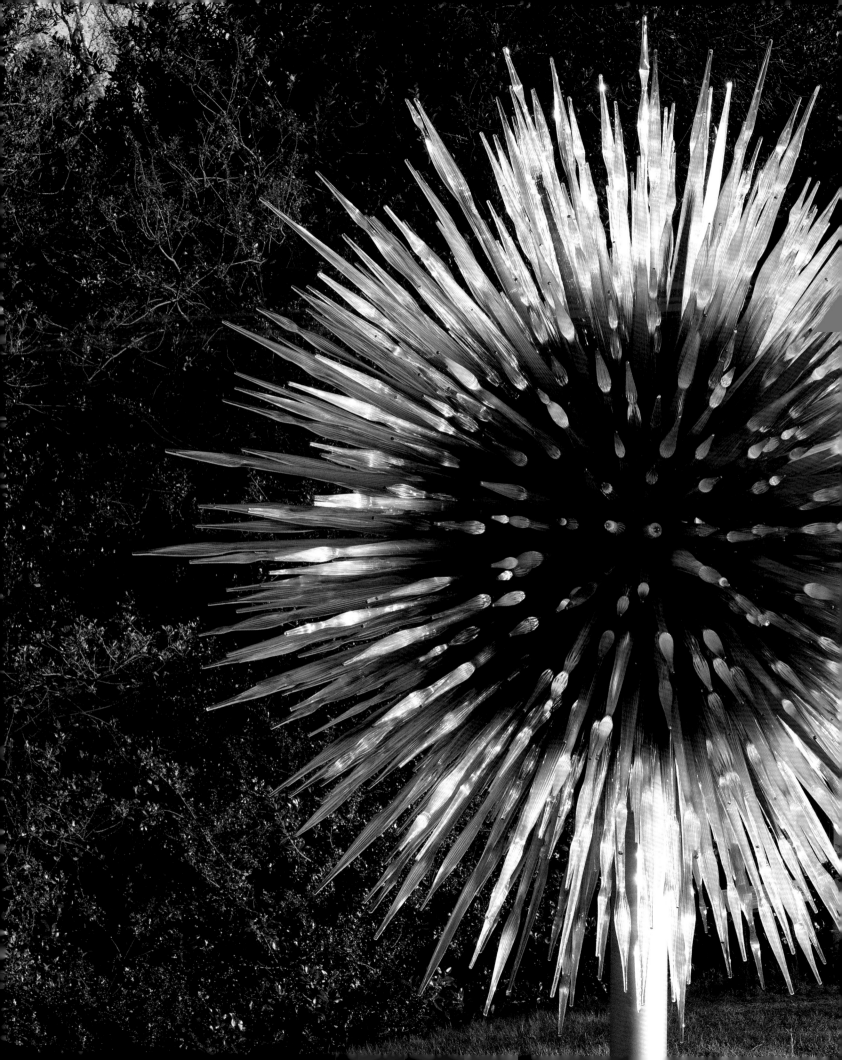

# Foreword

This book celebrates the work of iconic artist Dale Chihuly and his second show in the landscape of the Royal Botanic Gardens, Kew. It gives me great pleasure to welcome Chihuly back to Kew, having visited his 2005 exhibition here many times. This was a real turning point for Kew in terms of being seen as an arts venue. It proved incredibly successful – so much so that we had to extend it due to popular demand.

A reverie of form, colour, and light, Chihuly's exquisite artworks are often described as exaggerated celebrations of what is found in nature. As the most biodiverse place on the planet – more so than the Amazon rainforest – Kew Gardens' breath-taking glasshouses, vistas and galleries are the ideal home for such work.

The 22 stunning installations situated across the Gardens in 13 locations demonstrate the evolution of the artist's career over 50 years. The Gallery artworks show the development of his expressive lines and abstract forms, as well as the most technically challenging work Chihuly and his team have ever created. His large-scale installations are breath-taking and particularly in the setting of Kew, show both their similarities to plant life in terms of light and form, and their differences – the graceful, luminous colour sitting within the solid earthiness of nature.

The pages of this book capture not only the latest show at Kew but also provide background to Dale Chihuly himself and insight into the physicality of the creative process. I was lucky enough to experience this during a visit to Chihuly Studio in Seattle where I saw the 'Chihuly Team' – master glassblowers – working in the hotshop, observing the extraordinary skill and creativity of work with molten glass, the addition of colour and shaping to produce beautiful and enduring artworks.

Chihuly at Kew truly celebrates art as both inspired by and in collaboration with nature. Bold and beautiful, surreal and seductive, these works stimulate the imaginations of all who experience them.

*Sapphire Star* (detail), 2010
Blown glass and steel
290 x 287 x 287 cm
(114 x 113 x 113")
Royal Botanic Gardens, Kew,
installed 2019

**Richard Deverell**
Director (CEO), Royal Botanic Gardens, Kew

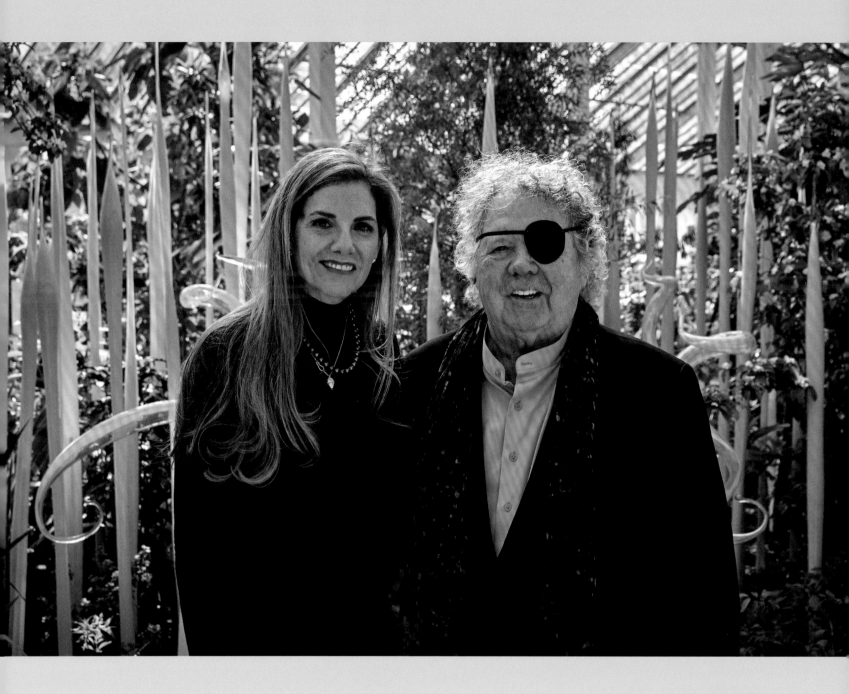

Leslie and Dale Chihuly
Royal Botanic Gardens, Kew,
2019

**Greetings from
the Boathouse**

It's been 50 years since
I first visited Kew. The
Palm House was the most
beautiful structure I had
ever seen and now that
the Temperate House has
been restored I can't wait
to be there. Is it really the
largest greenhouse in the
world. See you soon.

Love to All, Chihuly
& Leslie

1.28.19

# Artist's statement

**Dale Chihuly**

1111 NW 50th Street
Seattle, WA 98107
Tel   206 781 8707
Fax  206 781 1906

dale@chihuly.com
www.chihuly.com

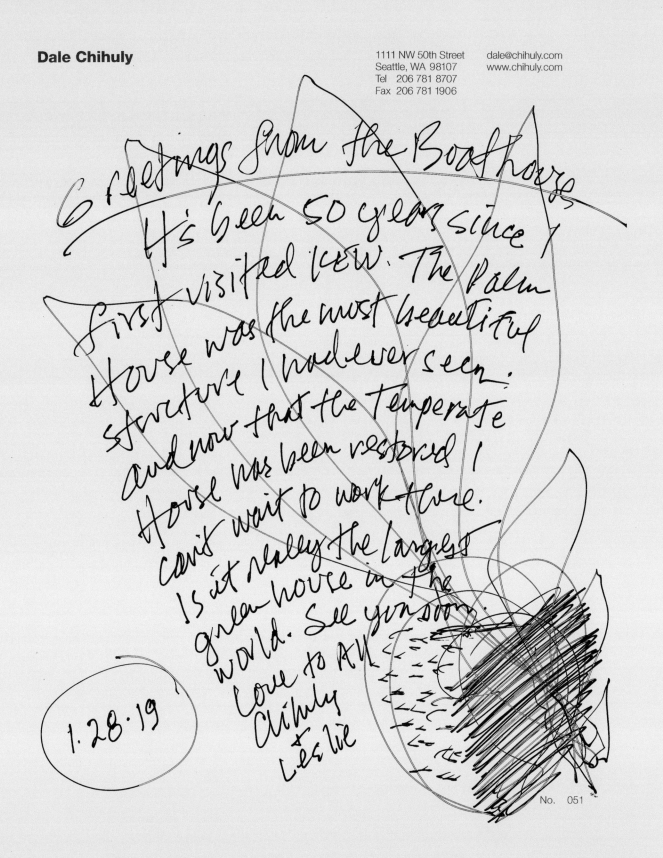

Greetings from the Boathouse,
It's been 50 years since I
first visited Kew. The Palm
House was the most beautiful
structure I had ever seen.
and now that the Temperate
House has been restored I
can't wait to work there.
Is it really the largest
greenhouse in the
world. See you soon.
Love to All
Chihuly
& Leslie

1.28.19

No.  051

# AN INTRODUCTION
# TO DALE CHIHULY

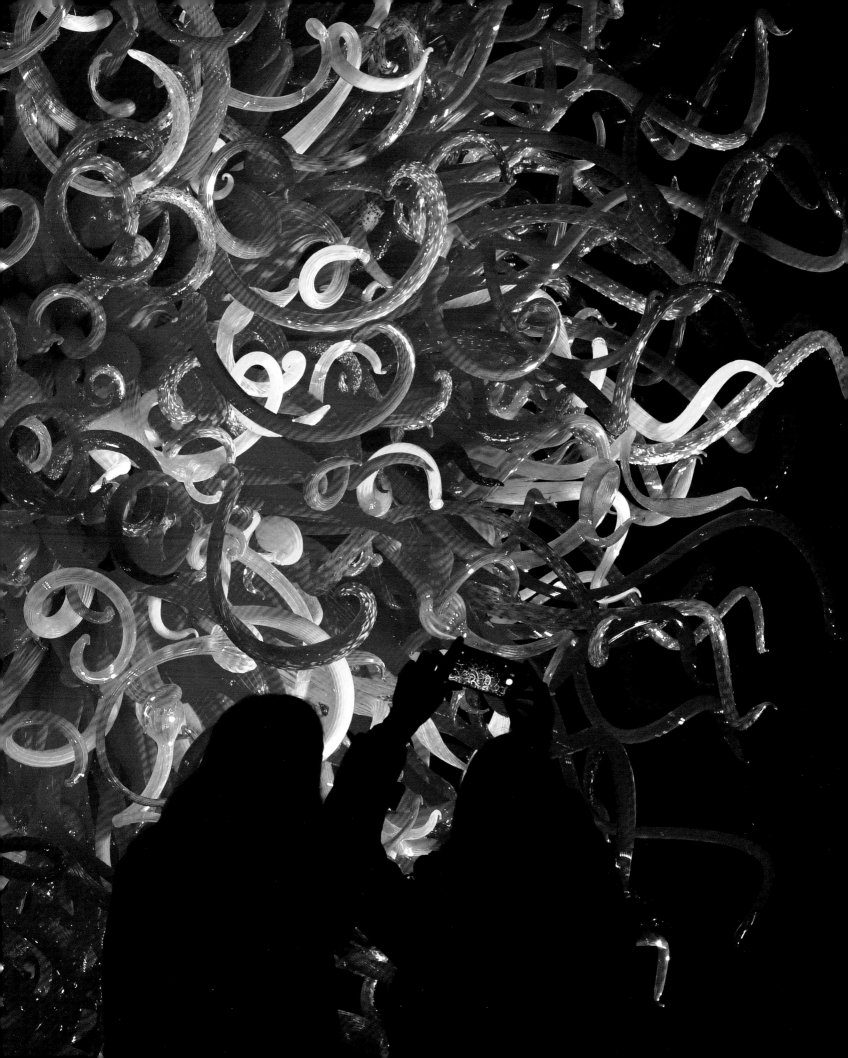

Born in 1941 in Tacoma, Washington, USA, Dale Chihuly was introduced to glass while studying interior design at the University of Washington. After graduating in 1965 he enrolled in the first hot glass programme in the USA, at the University of Wisconsin. His studies continued at the Rhode Island School of Design, where he later established the glass programme and taught for more than a decade.

In 1968, as the recipient of a Fulbright Fellowship, Chihuly went to work at the Venini glass factory in Venice, Italy. There he observed the team approach to blowing glass, which is critical to the way he works today. In 1971, Chihuly cofounded the Pilchuck Glass School in Washington State. With this international glass centre, the most comprehensive of its kind in the world, Chihuly has led the avant-garde in the development of glass as a fine art.

His work is included in more than 200 museum collections worldwide. His many awards include 13 honorary doctorates and two fellowships from the US National Endowment for the Arts.

Chihuly has created more than a dozen well-known series of works; *Cylinders* and *Baskets* in the 1970s; *Seaforms*, *Macchia*, *Persians*, and *Venetians* in the 1980s; *Niijima Floats* and *Chandeliers* in the 1990s; and *Fiori* in the 2000s. He is also celebrated for large architectural installations. In 1986, he was honoured with a solo exhibition, *Dale Chihuly Objets de Verre* at the Musée des Arts Décoratifs, in the Palais du Louvre, Paris. He initiated *Chihuly Over Venice* in 1995, creating sculptures at glass factories in Finland, Ireland, and Mexico, for installation over the canals and piazzas of Venice. More than one million visitors attended the Tower of David Museum to view his ambitious installations for *Chihuly in the Light of Jerusalem 2000*. In 2001, London's Victoria and Albert Museum curated *Chihuly at the V&A*.

His lifelong fascination with glasshouses has grown into a series of exhibitions in botanical settings. *The Garden Cycle* began in 2001 at the Garfield Park Conservatory, Chicago,

and has continued at many locations, among them the New York Botanical Garden (2006 and 2017) and the Royal Botanic Gardens, Kew (2005 and 2019). *Chihuly Garden and Glass*, a major long-term exhibition, opened in Seattle in 2012.

Chihuly has also exhibited at other venues including the de Young Museum, San Francisco (2008); the Museum of Fine Arts, Boston (2011); the Virginia Museum of Fine Arts, Richmond (2012); the Montreal Museum of Fine Arts (2013); the Glass Art Museum, Toyama (2015); the Royal Ontario Museum, Toronto (2016); the Crystal Bridges Museum of American Art, Bentonville, Arkansas (2017); Centre for Contemporary Art, Prague (2018) and the Groninger Museum, Groningen (2018).

A prodigiously prolific artist whose work balances content with an investigation of the material's properties of translucency and transparency, Chihuly began working with glass at a time when reverence for the medium and for technique was paramount. Although he had been a student of interior design and architecture in the early 1960s, by 1965 he had become captivated by the process of glassblowing.

Influenced by an environment that fostered the blurring of boundaries separating the arts, as early as 1967 Chihuly was using neon, argon, and blown glass forms to create room-sized installations of organic, freestanding, plant-like imagery. He brought this interdisciplinary approach to the arts to the legendary Pilchuck School, serving as artistic director until 1990. Under Chihuly's guidance, Pilchuck became a gathering place for international artists from diverse backgrounds. Over the years his studios, which include an old racing shell factory in Seattle called The Boathouse and buildings in the Ballard section of the city and Tacoma, have been a mecca for artists, collectors, and museum professionals involved in all media. In addition to being working environments, they house diverse and massive collections ranging from Pendleton blankets to chalk-ware figurines that in their quantities as well as qualities may have provided additional inspiration to the artist over time.

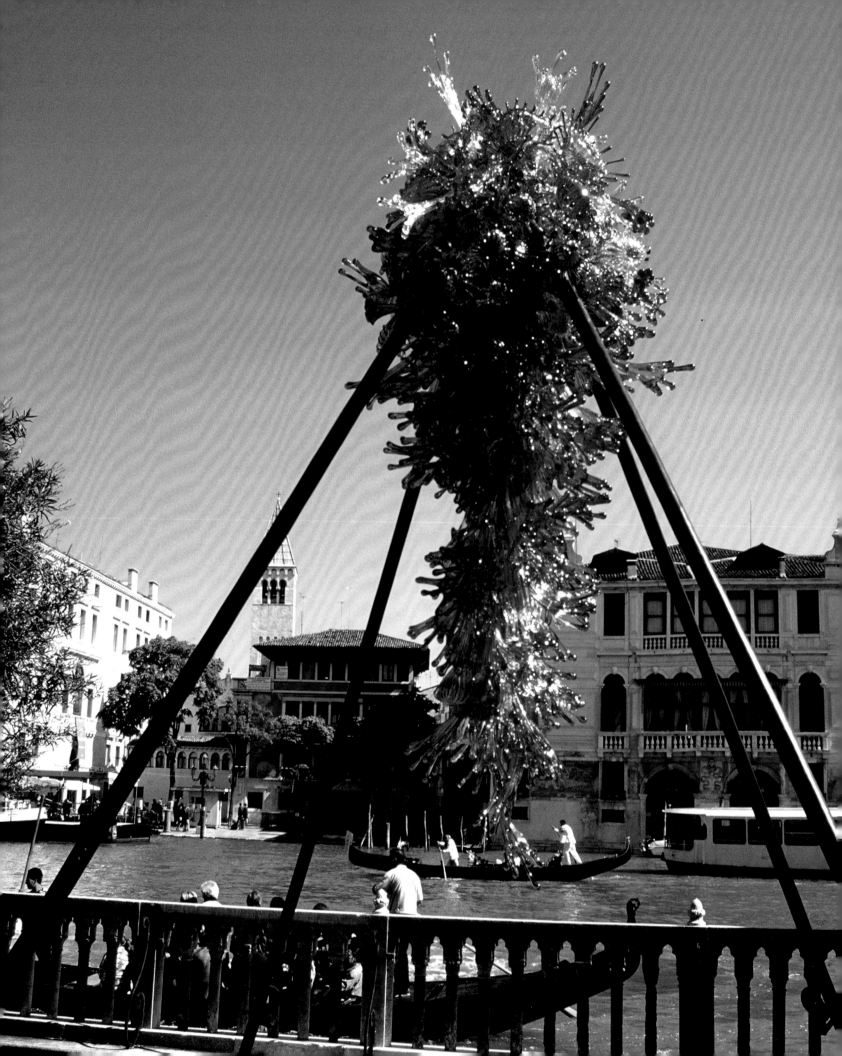

Stylistically, for over 40 years, Chihuly's sculptures in glass have explored colour, line, and assemblage. Although his work ranges from the single vessel to outdoor installations, he is best known for his multipart blown compositions. These works fall into categories of mini-environments designed for the table top as well as large, innovatively displayed groupings on a wide variety of surfaces ranging from pedestals to bodies of natural water. These blown forms have also been affixed en masse to specially engineered structures that dominate large exterior or interior spaces. In recent years, Chihuly has experimented with the plastic Polyvitro to create works that could not have been made safely in glass for their environments.

Chihuly and his teams have created a wide vocabulary of blown forms, revisiting and refining earlier shapes while at the same time creating exciting new elements. His *Fiori*, beginning in the early 2000s, continue to demonstrate his desire to showcase the glassblowing skills of his teams, including gaffers William Morris, Rich Royal, Martin Blank, Joey Kirkpatrick, Flora Mace, Joey DeCamp, Benjamin Moore, Jim Mongrain, Lino Tagliapietra, and Pino Signoretto. The *Baskets*, *Cylinders*, *Seaforms*, *Macchia*, *Persians*, *Venetians*, *Niijima Floats*, and *Chandeliers* have been joined by newer blown elements: *Reeds*, *Saguaros*, *Herons*, *Seal Pups*, and *Belugas*. The array demonstrates that Chihuly is, first and foremost, a colourist.

Chihuly's work is also marked by the prominence of line. His *Blanket Cylinders* of the mid-1970s, for example, were unique within the history of glass because of the composed glass-thread 'drawings' fused into the surface. Later, the *Seaforms* were blown in optic moulds, resulting in surfaces decorated with repeating ribbed motifs. The *Macchia* series explored bold, colourful lip wraps that contrast sharply with the brilliant body colours of the vessels. Finally, beginning with the *Venetians* of the early 1990s, the elongated, linear blown forms, that are a product of the glassblowing process, became significant parts of his vocabulary. These highly baroque, sometimes writhing elements are especially effective in the more recent *Chandeliers*, *Towers*, and *Boats*.

Flora C. Mace, Seaver Leslie,
Chihuly, and Joey Kirkpatrick
The Boathouse hotshop,
Seattle, 2013

*'Glass is one of the only materials that transmits light and colors can be so intense or so subtle'.*

Dale Chihuly

*Temperate House Persians*
(detail), 2018
Blown glass and steel
996 x 239 x 213 cm
(392 x 94 x 84")
Royal Botanic Gardens, Kew,
installed 2019

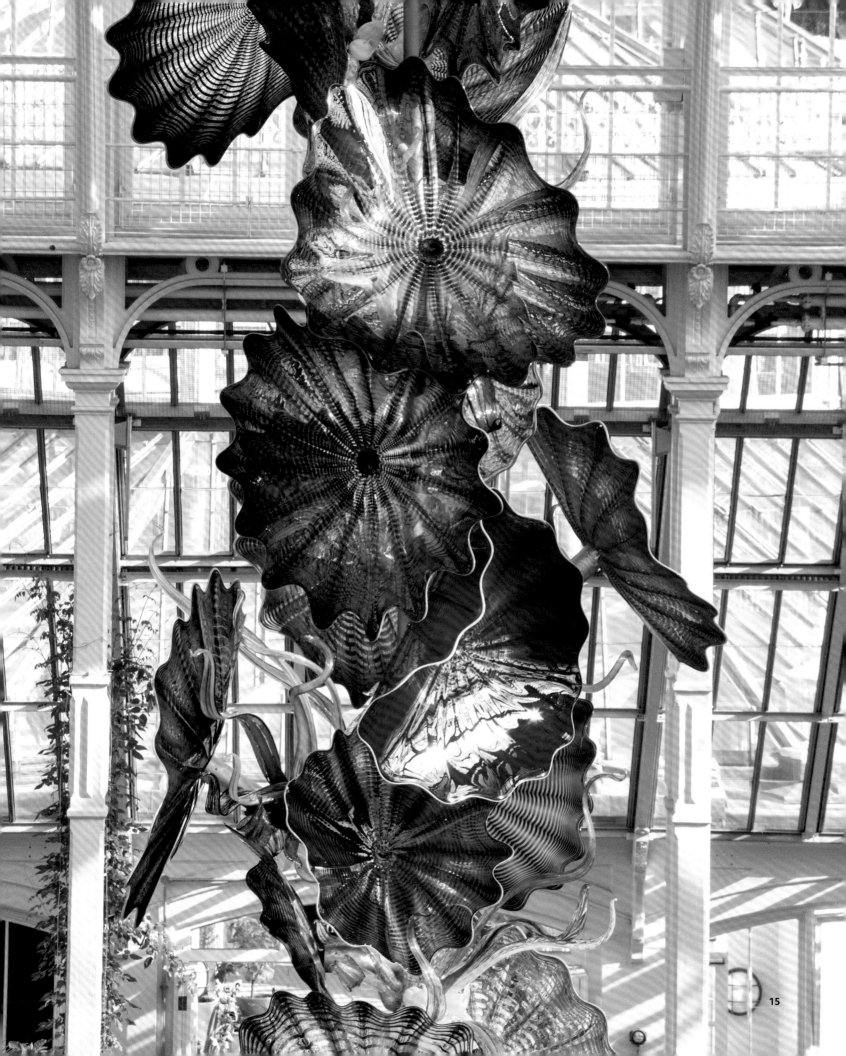

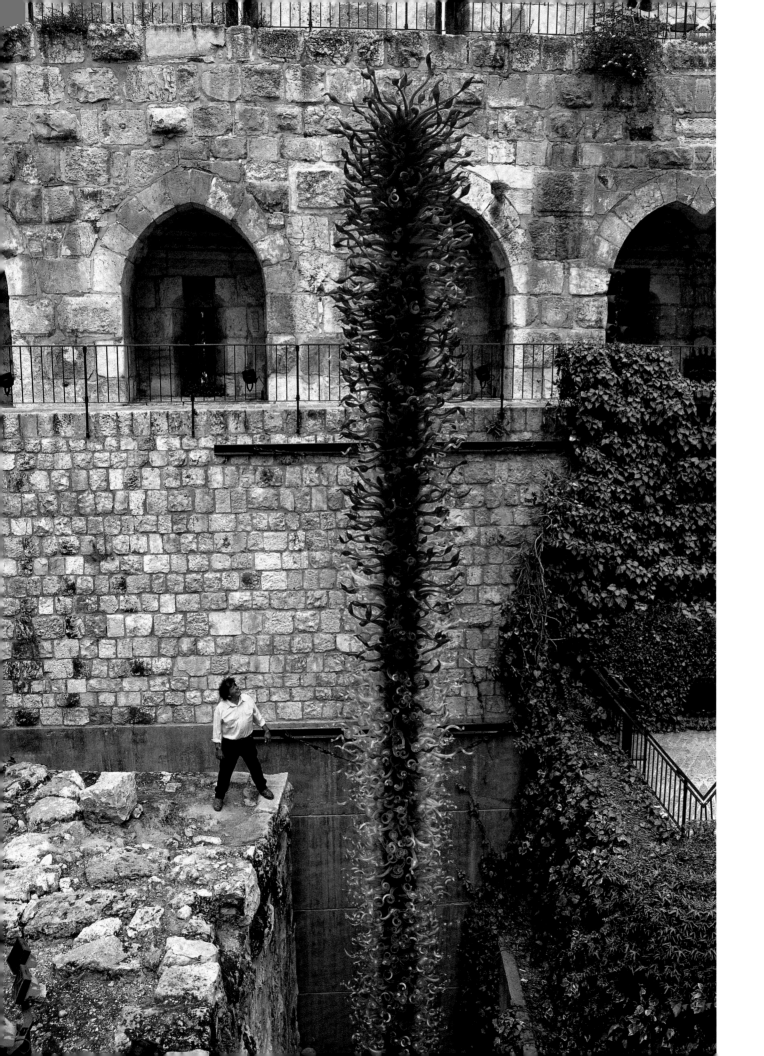

The works on paper, begun in the late 1970s as an activity to occupy his time while working with the teams in the hotshop and as a means of communicating ideas to the team, demonstrate that same linear quality. Whether executed with pencil, mixed media or acrylic paint, attenuated lines dominate these compositions.

Chihuly's work is strongly autobiographical. Recently, the artist has become more forthcoming about the influence of his family on his work. He attributes his success with teamwork to his father, who was a union organiser. His well-documented close relationship with his mother is now understood to have been strengthened by the death of his older brother in 1957 and then his father a year later. One of her most lasting influences is in his longstanding fascination with abstracted flower forms – an allusion to her lush gardens in Tacoma, Washington. Likewise, series such as his *Seaforms*, *Niijima Floats*, and even the *Chandeliers* allude to his Tacoma childhood, marked by his love of the sea and his recognition of its importance to the economy of the Pacific Northwest. The *Basket* series developed from the woven Northwest Coast Indian baskets he saw at the Tacoma Historical Society in 1977, with his late friend the sculptor Italo Scanga and sculptor James Carpenter.

Over the years the artist has created a number of memorable installation exhibitions. These confirm his sensitivity to architectural context and his interest in the interplay of natural light on the glass that exploits its translucency and transparency. While elements of earlier installations allude to natural phenomena such as icicles and vegetation, gardens provide the dominant theme in more recent ones. Sites such as the Royal Botanic Gardens, Kew and the New York Botanical Garden have enabled the artist to juxtapose monumental, organically shaped sculptural forms with beautiful landscaping, establishing a direct and immediate interaction between nature, art, and environmental light.

A dominant presence in the art world, Dale Chihuly and his work has long provoked considerable controversy in the art-craft debate. However, his lasting contribution to art of our times is an established fact. He can be lauded for moving the Studio Glass movement from its original premise of the solitary artist working in a studio environment on to a collaborative team endeavour with a division of labour aligned to the creative process. But his contribution extends well beyond this. His practice of bringing together teams of artists with exceptional glassblowing skills has led to the development of complex, multipart sculptures of dramatic beauty and scale. This places him in the vanguard of moving blown glass out of the confines of the small, precious-object genre into the realm of large-scale sculpture and environmental art. Chihuly deserves much of the credit for establishing the blown glass form as an accepted medium for installation art and, hence, for its expression in late twentieth and twenty-first century art.

Dale Chihuly with
*Blue Tower*
Jerusalem, 1999

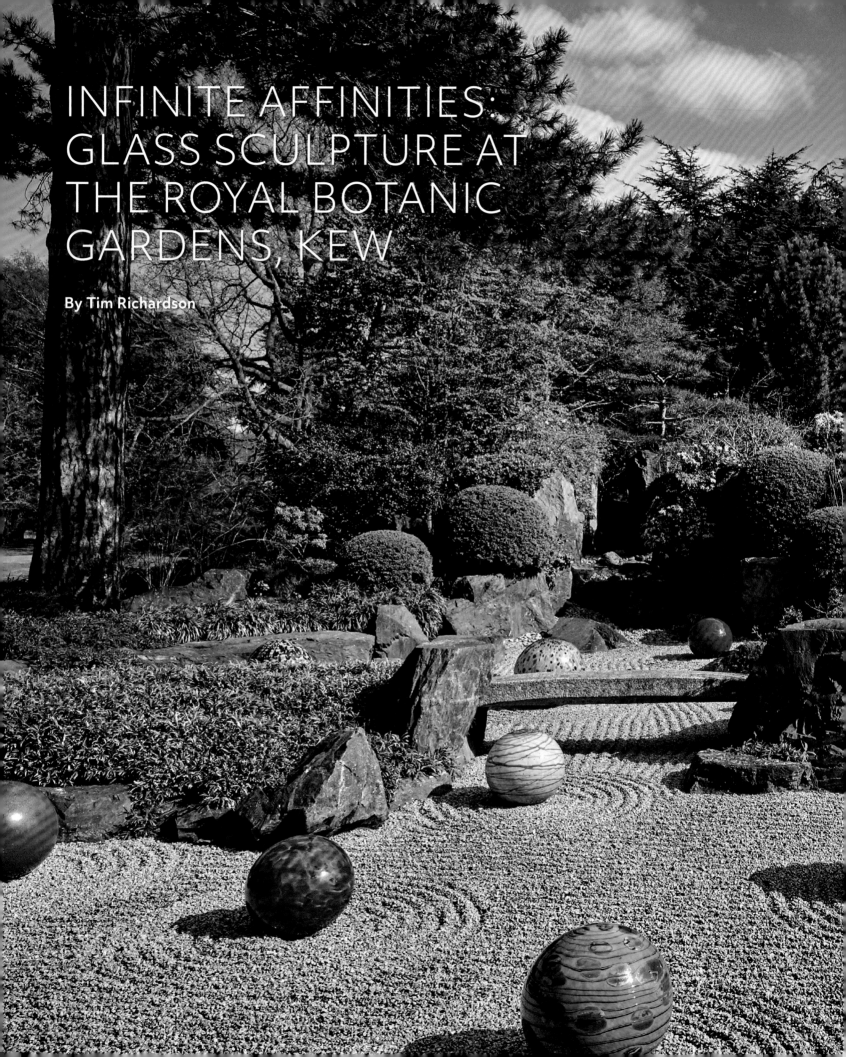

# INFINITE AFFINITIES: GLASS SCULPTURE AT THE ROYAL BOTANIC GARDENS, KEW

By Tim Richardson

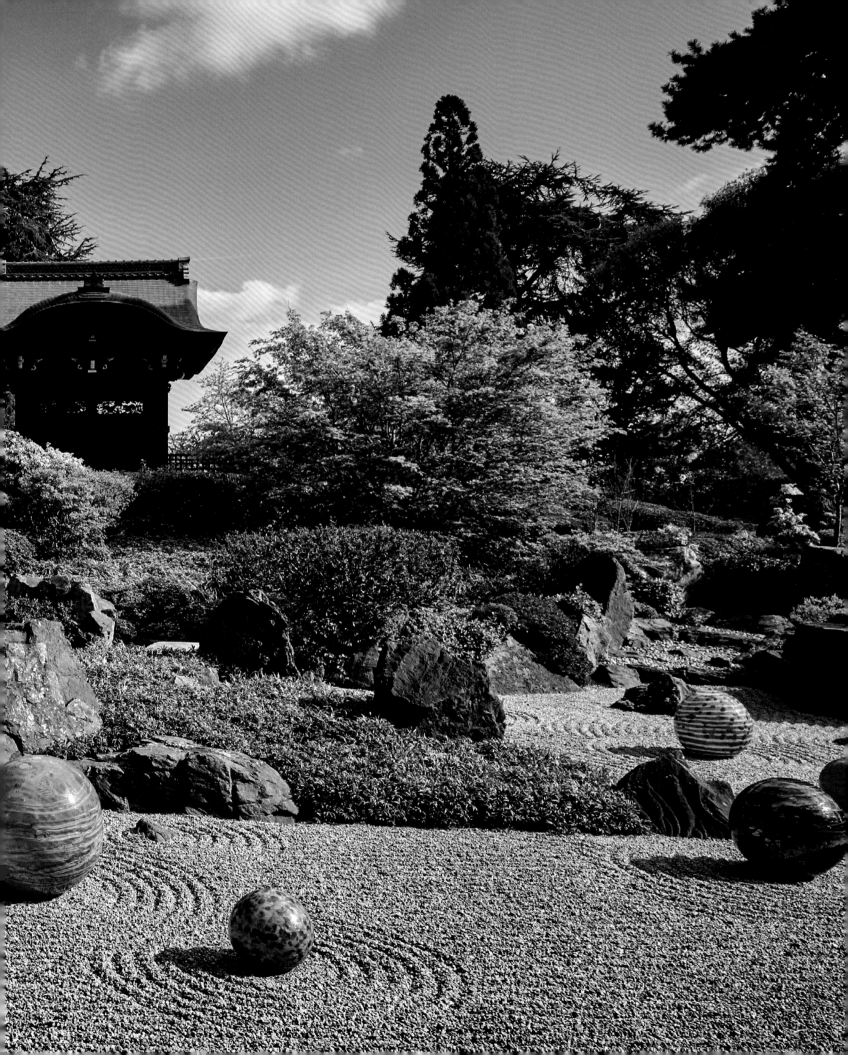

Dale Chihuly is an American artist who has since the 1960s made an international reputation as the creator of a wide range of sculptural forms which he fabricates with the help of a team of skilled glassblowers at his studio in Seattle. The semi-abstract forms and bright colours which characterise the work make it instantly recognisable, despite the fact Chihuly has developed numerous series over the years, ranging from huge *Chandelier*, *Tower* and *Sun* sculptures bristling with tentacles or tendrils, to much smaller and more delicate objects imbued with painterly detail on their surfaces. His work can be found in scores of galleries and museums around the world – many British people will be familiar with the *V&A Rotunda Chandelier* (2001) that hangs in the grand entrance of the Victoria & Albert Museum in London. Now, in 2019, he is making a second visit to the Royal Botanic Gardens, Kew with an exhibition entitled *Chihuly: Reflections on nature*.

Born and raised in Tacoma, near Seattle, Chihuly's parents were Hungarian, Czech and Slavic on his father's side, and Swedish and Norwegian on his mother's. He recalls:

I grew up in a house that had a large garden. My mother worked in the garden every day, about eight hours a day. It had about 90 rhododendrons and azaleas and I would play in the garden with my little toy soldiers and so on. I would play in the garden but I never helped my mother. I don't know why that is – I loved seeing the flowers but I never gardened. Every now and then, after I had left, she would find a little toy soldier.

Chihuly started blowing glass in 1966, studying on what was then the only course in the United States, later working alongside the celebrated Venini art-glass blowers on the island of Murano, near Venice. Chihuly's experiences there inspired his collaborative approach to glass-blowing, in which he is a 'gaffer' who oversees a group of blowers – one of whom will sometimes stand on an articulated lift, to allow him to blow the very tall pieces. In 1976 Chihuly was injured in a car accident in England in which he lost an eye; a few years later, in 1979, he stopped blowing glass himself after a body surfing accident. His declared influences are Native American craft forms,

Japanese ikebana and Venetian art glass of the 1920s and 1930s. But that is just the start.

Chihuly's engagement with the world of botanic gardens is a relatively recent development in the context of his long career. It began in 2001 with a display in the Garfield Park Conservatory in Chicago and continued with conservatory-based exhibitions in Columbus, Ohio, and Atlanta, Georgia, before in 2005 he came to Kew for his most ambitious exhibition to date. This first London excursion was a huge success (the exhibition was extended due to popular demand), opening an entirely new perspective on the work and leading to more shows at botanic gardens across the United States. The word show seems appropriate, as there is a stage-set theatricality to the displays which Chihuly gladly acknowledges is part of the appeal.

Over the years Chihuly has developed a multifarious vocabulary of glass forms: tall columns, elegantly stooping *Herons*, thin *Reeds*, clamshell-like *Macchia*, glittering *Chandeliers*, bulbs and boats floating on lakes, and climactic towers and *Suns*. Few of the pieces are based on specific botanical forms, but there is no shortage of bulbous gourds, curly tendrils and arching stalks.

Each botanic-garden exhibition is individually curated so that every installation within it is unique to its specific site. New pieces are specially made for every show. The displays have elicited a rapturous response among many visitors, who seem to have an instinctive appreciation of the appropriateness of this work in a garden context. Given that these are works of art (artificial) embedded and interpolated with botanical specimens (natural), the strength of this response could hardly be predicted. But it transpires that the qualities of endless variation on themes and uncompromising, vivid colour seems to work well in the garden context, both indoors and outdoors. The violence of the colouring and the element of mutation between individual pieces, within specific series of works, makes Chihuly's glass sculptures seem more, rather than less natural. It is certainly not for the colour-phobic, which is perhaps why the work has been so warmly received by a botanically literate audience – gardeners being, by and large, entirely comfortable with the concept of colour.

Previous page:
*Niijima Floats*, 2019
Blown glass
Royal Botanic Gardens, Kew

Dale Chihuly
University of Wisconsin,
Madison, c. 1967

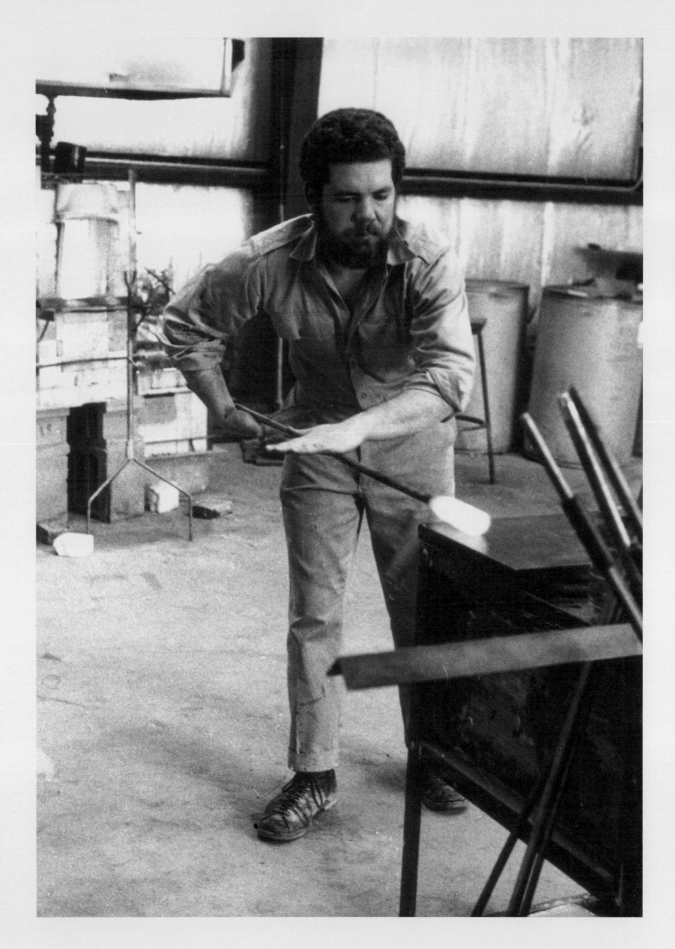

*'I want people to be overwhelmed with light and color in a way they've never experienced'.*

Dale Chihuly

*Neodymium Reeds and Turquoise Marlins* (detail)
Blown glass
305 x 1920 x 1433 cm
(120 x 756 x 564")
Royal Botanic Gardens, Kew,
installed 2019

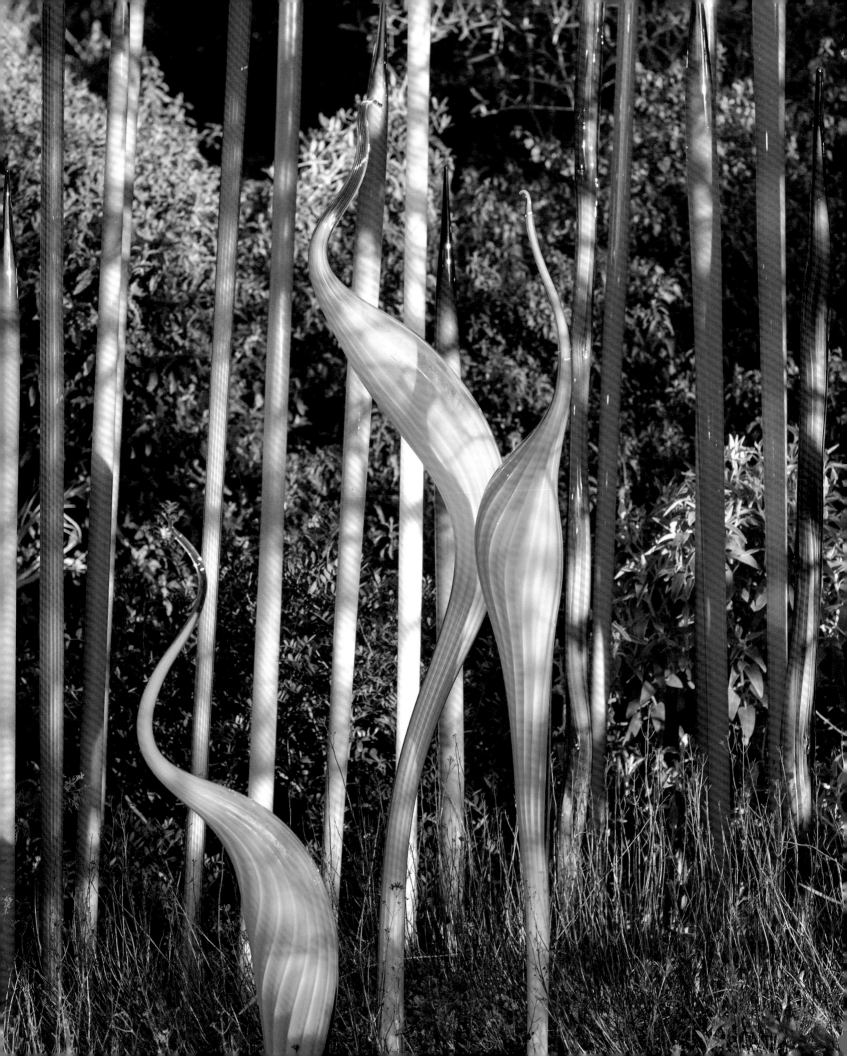

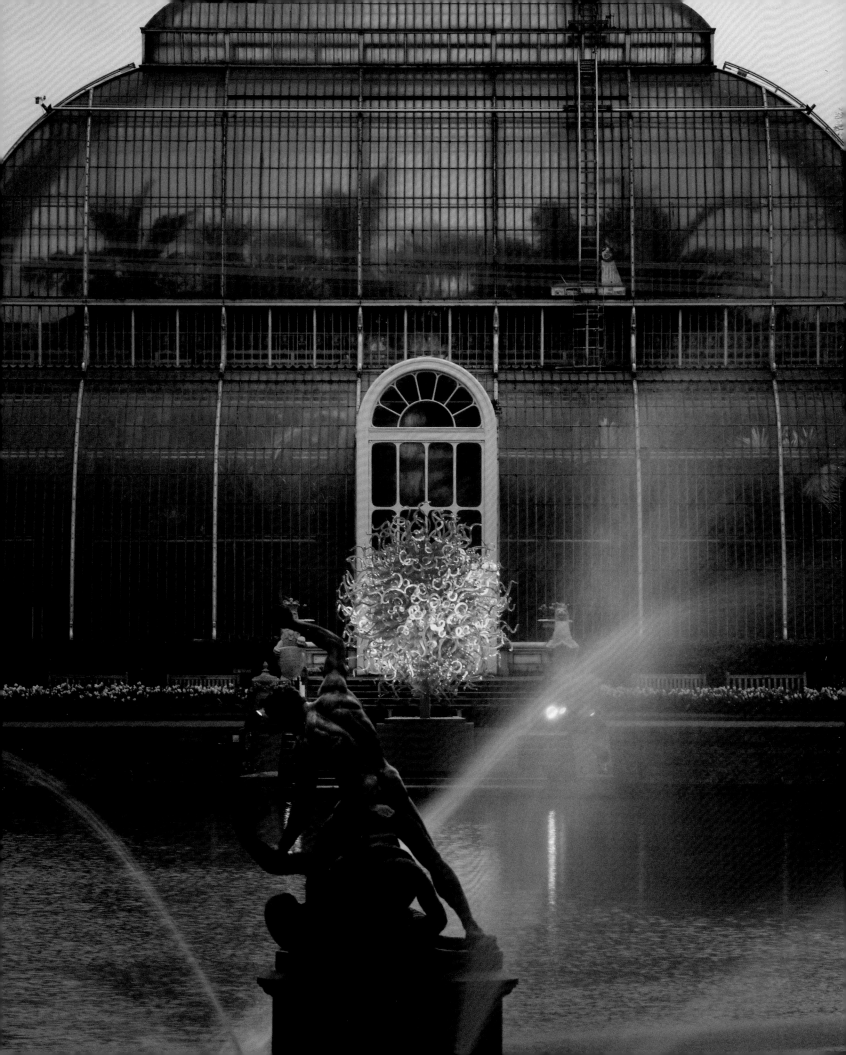

In *The Garden Cycle*, as this suite of exhibitions is known at Chihuly's studio, the artist has explored and deepened the affinities which have emerged between his sculpture and the botanical realm. These similarities may not seem immediately obvious – glass being hard, brittle, artificial, dead and unchanging in form, at least when the molten material has cooled. Plants, of course, possess many qualities which set them apart from glass objects, not least their capacity for growth and change – sometimes so fast it is visible over the course of a day – and their reproductive capacity.

Yet the concept of an affinity between plants and Chihuly's works in glass captures something of the intensity of the relationship when they are juxtaposed. In relation to natural history, the *Oxford English Dictionary* defines affinity as: 'structural resemblance between different animals, plants, or minerals, suggesting modifications of one primary type, or (in the case of the two former) gradual differentiation from a common stock.' Darwin is cited as using the term in relation to the similarities between different species of orchid.

Chihuly does not consciously mimic plant forms in his work, yet it turns out that his sculptures in glass have more in common with the world of plants than might perhaps be expected. In fact, the affinities can seem almost uncanny. Coloured, squirming and writhing pieces of glass seem to reflect the fecundity and variety of plants in the wild, in the violence of their colouring and the unpredictability of their forms. Chihuly's series have all developed gradually over decades, and multicoloured 'mistakes' or mutations are displayed alongside more perfect examples, just as in nature during the slow process of natural selection. As Chihuly has commented:

> With glass-blowing, the only way to make it good is
> to do it over and over. It's a question of time. You just
> have to become one with the material and understand it.
> You can't see it; you have to feel it.

There are other affinities. Light transforms the colour of glass as it does petals and foliage, and the frozen fluidity of blown glass captures something of the organic dynamism of plant life. Blown glass is also surprisingly tough, just like petals or leaves.

The work process is in fact analogous to the self-sustaining regimes of nature. The idea of evolution in an artist's practice is an overused analogy, but it is perhaps relevant here because variation, repetition, death (in the sense of material failure) and selection are constant themes in Chihuly's work. The idea of a series being perfected or finished is anathema to him. As he has stated of his *Macchia* series, 'like much of my work, the series inspired itself.'

A sense of evolution in the work partly stems from Chihuly's working methods. 'I think a lot of it comes from the fact that we don't like to use a lot of tools,' he has commented, 'but natural elements to make the glass – fire, gravity, centrifugal force. As a result, it begins to look like it was made by nature.'

This sense of spontaneity has been translated to the way Chihuly approaches the botanic-garden projects as complete artworks in themselves. There is no overall plan or theme to each display. 'We don't try to create a particular rhythm,' says Chihuly, 'we just try to make each installation as beautiful as we can. They should work together naturally.' The exhibitions are always planned out spontaneously during site visits. 'So much of it has to do with the way I feel at the time, when I do my walk around the garden,' he explains.

The relevance of Chihuly's sculpture to scientific institutions such as Kew, and the research work carried out there, is that these works in glass show plants in a new and different light. They emphasise plants curious forms, certainly, but also highlight the sheer variety inherent even among specimens of the same species. During the six-month exhibition at Kew, plants will grow around and entwine with the sculptures, in some cases almost overwhelming them, which is all part of the artist's intention.

Education is an important aspect of the mission of the Royal Botanic Gardens, Kew. Chihuly's sculptures complement the forms of the natural world so that anyone who feels overawed by the complexity of matters such as taxonomy (all those Latin names) might find a way in to the world of plants through these works. On the other hand, those who are already comfortable in the botanical world might find that the exhibition opens their eyes to the possibility of contemporary sculpture, since the sensual joy inspired by Chihuly's work is arguably very similar to the feelings engendered by burgeoning plant life.

*Summer Sun*, 2010
Blown glass and steel
411 x 406 x 394 cm
(162 x 160 x 155")
Royal Botanic Gardens, Kew,
installed 2019

A garden is a much more democratic environment than an art gallery, where occasional visitors can feel like interlopers. The outdoor setting frees up visitors so that they can enjoy the work without feeling overburdened by the social and cultural hierarchy of the art world. At Kew there is also a historical component: before it became a botanic garden open to the public in the late eighteenth century, the Kew site was divided in two as a pair of royal residencies, the White House and Richmond Lodge. Both gardens had a strong artistic component and that legacy remains today in, for example, William Chambers' Pagoda and temples and the architectural fantasia that is the Palm House. It seems appropriate to display art here, which is perhaps a factor in the success of exhibitions devoted to the work of artists such as Henry Moore and David Nash.

Now that Chihuly has returned to Kew, 14 years on, it is possible to appreciate the development of the work and the subtle shift in attitude shown through the siting of works and choice of forms. While works in the 2019 Kew display are still primarily sculpted from glass, some are formed from Polyvitro. There are still moments of high drama, when large-scale pieces erupt out of the herbage, for example. But there is now more of an emphasis – more confidence, perhaps – in allowing the artworks to work together with the plants, emphasising their affinities perhaps more than their contrasting forms and colours, as well as an interest in creating episodes which function at a landscape scale. There is also an opportunity to see a different side to Chihuly's work in the indoor setting of the Shirley Sherwood Gallery, which is housing an exhibition of smaller, more detailed works produced in series since around 1980.

It will not take long before casual visitors to Kew realise that something rather different is going in the Royal Botanic Gardens. Chihuly's *Tower* or beacon pieces are dotted around the Gardens, from the cobalt blue *Sapphire Star*, provocatively placed on the grassy slope below the Temple of Bellona near Victoria Gate, to the *Scarlet and Yellow Icicle Tower* part-way along Syon Vista, which stretches from the Palm House to the River Thames. Then there is the tangled ball of brilliant red and yellow glass tendrils entitled *Summer Sun*, overlooking the pond next to the Palm House. These explosive, large-scale pieces are new twists on forms previously developed by Chihuly.

The chunky, angular appearance of the *Lime Crystal Tower* may seem less familiar, its pure colour contrasting with the complex green, brown and grey tones in the grass and trees planted around the Galleries.

The early botanic-garden exhibitions were conceived primarily as indoor events, as Chihuly recalls:

> It all started off at Garfield Park in Chicago. That was a huge glasshouse: 50,000 square feet. I've always loved glasshouses and I felt quite comfortable in them. Later we started working outside and in places where there were hardly any glasshouses. I found there was not a real difference working indoors and outside – you just had to get used to it. It just has a different feeling.

Chihuly says that the realisation that his glass pieces integrate well with the great outdoors came to him early in his career, when he was considering how best to photograph them:

> Since the very beginning I've always photographed my work outside in the landscape – I always knew it looked good outside . . . I can see the photo in my head: up in Maine, among the big rocks and lichen and moss. My red organic pieces up against the green. Also in the desert; I worked in Tucson for a while and they looked good in that environment.

Chihuly's experimental siting of glass sculptures (sheets of hand-blown stained glass) in the landscape at the Artpark, New York State, over two weeks in 1975, is now acknowledged as an important moment in the development of Land Art and, in some ways, as a precursor of the botanic-garden series initiated more than a quarter of a century later.

As the *Cycle* has progressed, Chihuly has become ever more interested in the placement of his works in established vistas. Chihuly's work possesses such material consistency and elemental power that it can stand up to a landscape setting, existing genuinely in balance with it. Perhaps the most dramatic expression of this in the current Kew show is the *Cattails* and *Copper Birch Reeds* episode.

*Lime Crystal Tower*, 2006
Polyvitro and steel
389 x 137 x 109 cm
(153 x 54 x 43")
Royal Botanic Gardens, Kew,
installed 2019

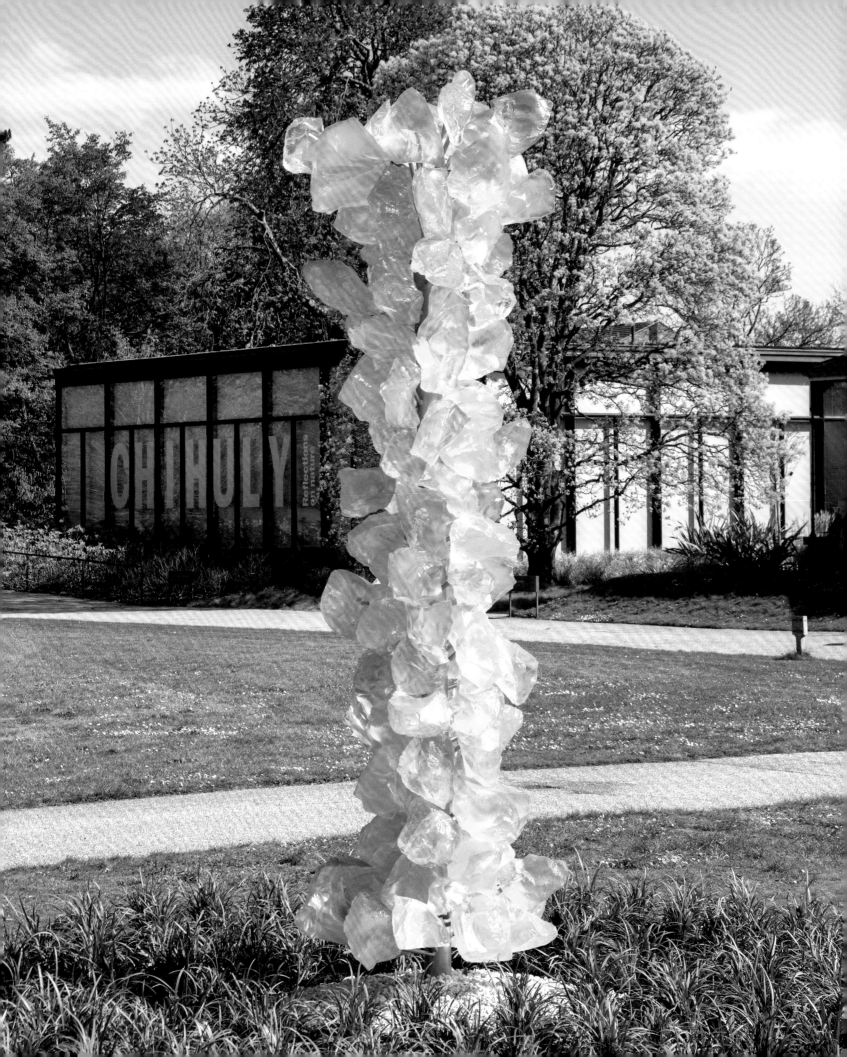

These curling red forms, positioned along the avenue of cherry trees linking the Temperate House with King William's Temple, illustrate the way Chihuly's glass sculptures cumulatively become a feature in the wider landscape design, as opposed to an installation in a discrete location.

On the slope beneath the elegant neoclassical portico of King William's Temple itself are gathered the *Neodymium Reeds* and *Turquoise Marlins*, their blues and purples acting as the climax to the cherry avenue display. Other exciting interventions involving reed forms can be found outside the Waterlily House (the *Red Reeds* series) and near the Medici Urn close to the Palm House pond (*Paintbrushes* series).

One of the most popular forms created by Chihuly is the globular *Niijima Floats* series, which are often floated on bodies of water. In the 2005 Kew exhibition they were memorably displayed in the water features of the Temperate House. Another effective setting for them, Chihuly has discovered, is a Japanese garden of rocks and gravel, and that is where they have been placed for this show. The colourful *Floats* give the scene an almost extraterrestrial appearance, temporarily making the idea of a Japanese garden without such adornments seem almost prosaic.

As ever with a Chihuly botanic-garden show, there is an important indoor element. At Kew there is a new twist, in that Chihuly's glassworks are being displayed in a traditional gallery setting, the Shirley Sherwood Gallery, without the juxtaposing presence of plants. This gives visitors the opportunity to appreciate the work in a more conventional manner, as sculptural objects. In the centre of the gallery is a display of the *Ikebana* series of delicate glassworks, while clustered in groups across the space are examples of the *Macchia*, *Seaforms*, *Venetians*, *Persians* and *Baskets* series, which in most cases Chihuly has been developing since 1977. The tortuously twisted yet strangely beautiful *Rotolo* series may be unfamiliar to some visitors, while the intricate markings on the *Cylinders* and *Soft Cylinders* pieces are a fascinating counterpoint to the large-scale works found outside, placing Chihuly squarely in the story of twentieth and twenty-first century abstract art. It is easy to forget how radical Chihuly's glass works were when he started in the late 1960s. 'Traditionally glass forms were always made in a symmetrical way,'

he recalls. 'What I did was start to make new and different forms.' A small selection of drawings provides insight into Chihuly's spontaneous working method and show how the integrity of the initial idea is cherished even as the piece takes material shape.

One display which is perhaps too easily missed is the *Ethereal White Persian Pond*, created in the Waterlily House. Clusters of pure-white forms have been installed in the central pond alongside its collection of huge-leaved *Victorian amazonica* waterlilies, making a beguiling contrast.

Finally, there is the Temperate House. This will likely be the highlight for those many visitors who revel in the sheer sensual delight of discovering these glass artworks interwoven with the burgeoning plant life; there is always a treasure-hunt element to a Chihuly garden exhibition.

Flanking the entrance to the conservatory like a frozen firework display are a pair of *Opal and Amber Towers*, luxuriantly decadent in their splendour, while just inside is a complementary *Opal and Gold Chandelier*. The dramatic centrepiece is the *Temperate House Persians* display: a column of flower-like forms in rich blue and lime-green shades, descending from the roof. Ranged across the Temperate House are various forms which will be new to Kew visitors: these include the *Turquoise Marlins* and *Floats* series, lurking in the undergrowth in their shiny splendour, the *Hebron Vessels* in cobalt blue, looking like archaeological artefacts, and the extraordinary *Beluga Boat*, with pure-white, balloon-like forms nested together in a hull. Perhaps most extraordinary of all is the *Fiori Verdi* installation in the Temperate House pond, with curling white ribbons and curious worm-like forms clustered together as bouquets on the water. It is also worth taking the time to seek out the delicate *Ikebana* pieces hanging from the trees, like epiphytic orchids growing among the surrounding tropical foliage.

Dale Chihuly's glass sculptures have once again descended on Kew as an alternative taxonomy of forms expressed as beautiful glass objects in many colours. These are gathered together as if to constitute different 'species' to be discovered among the natural fecundity and variation of the plant life on show at this great botanical institution. The result is a uniquely appealing conjugation of art and science.

*Ethereal White Persian Pond* (detail), 2018
Blown glass and steel
234 x 798 x 599 cm
(92 x 314 x 236")
Royal Botanic Gardens, Kew, installed 2019

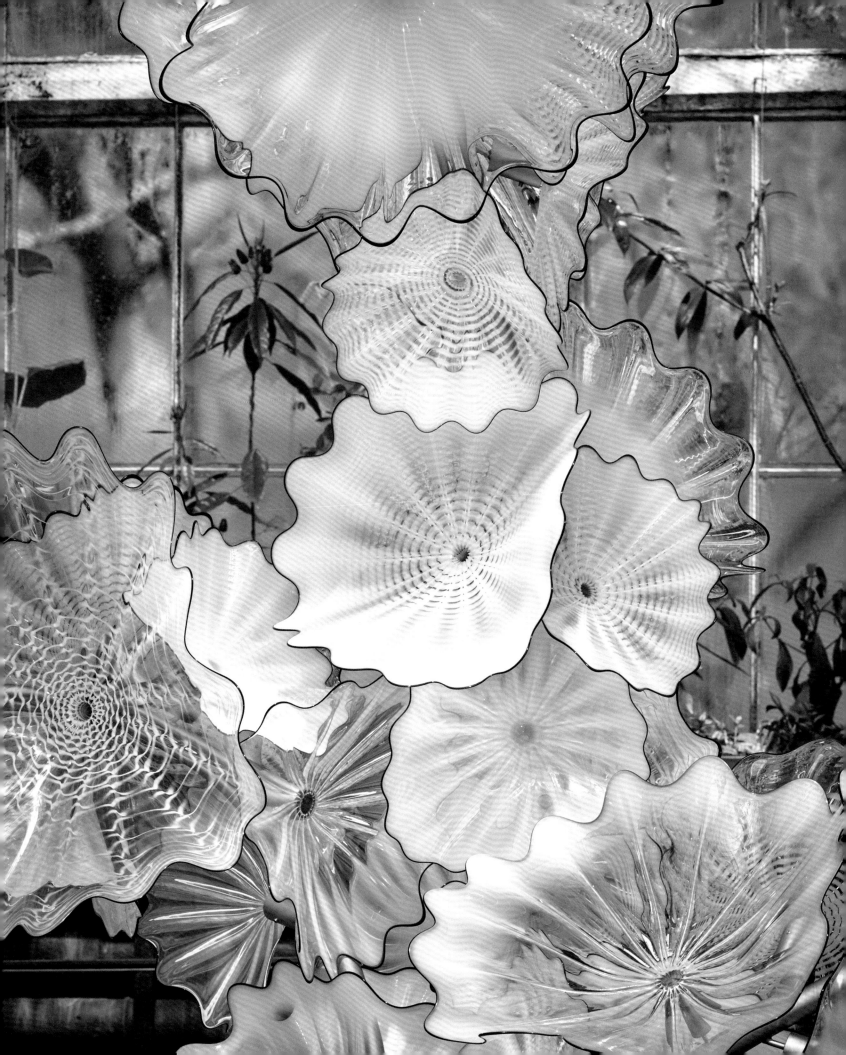

# CHIHULY: REFLECTIONS ON NATURE

One of the most daring and innovative artists working in glass, Chihuly's works have been described as 'reflecting the fecundity and variety of plants in the wild, both in the violence of their colouring and in the unpredictability of their forms'. Perhaps it is because of this that they sit so well in a botanic garden. Chihuly says 'I think a lot of it comes from the fact that we don't like to use a lot of tools, but natural elements to make the glass – fire, gravity, centrifugal force. As a result, it begins to look like it was made by nature.'

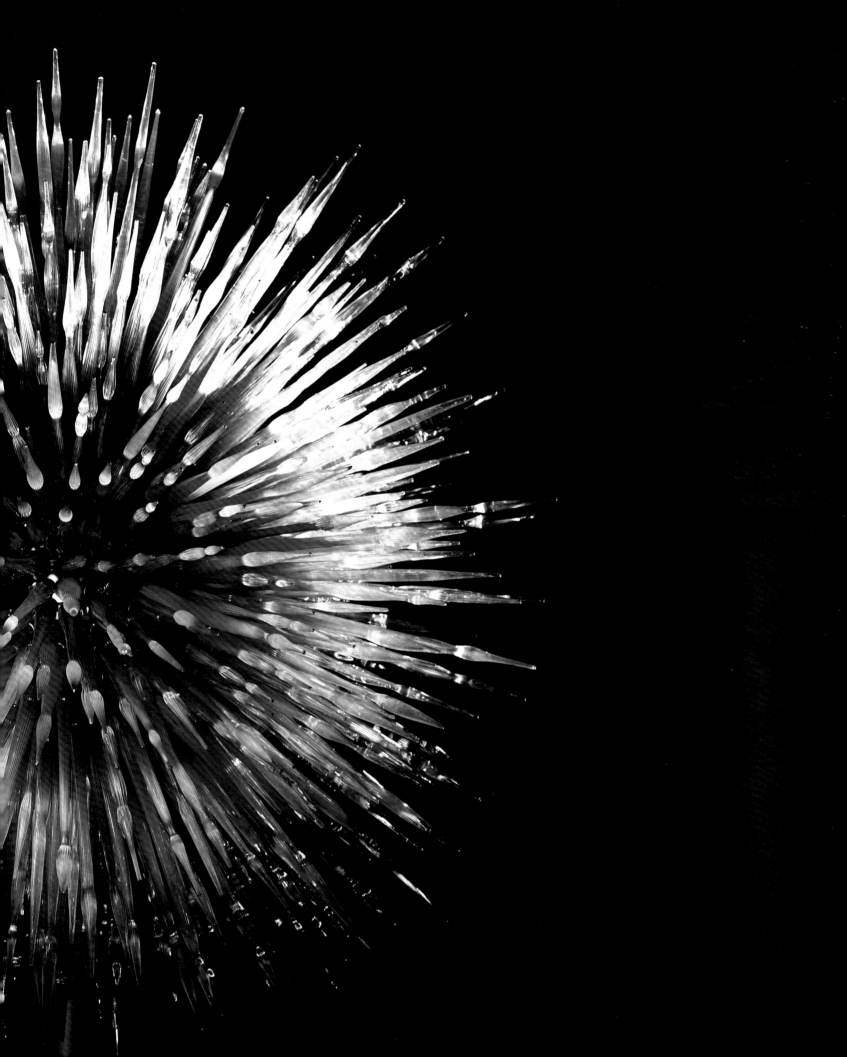

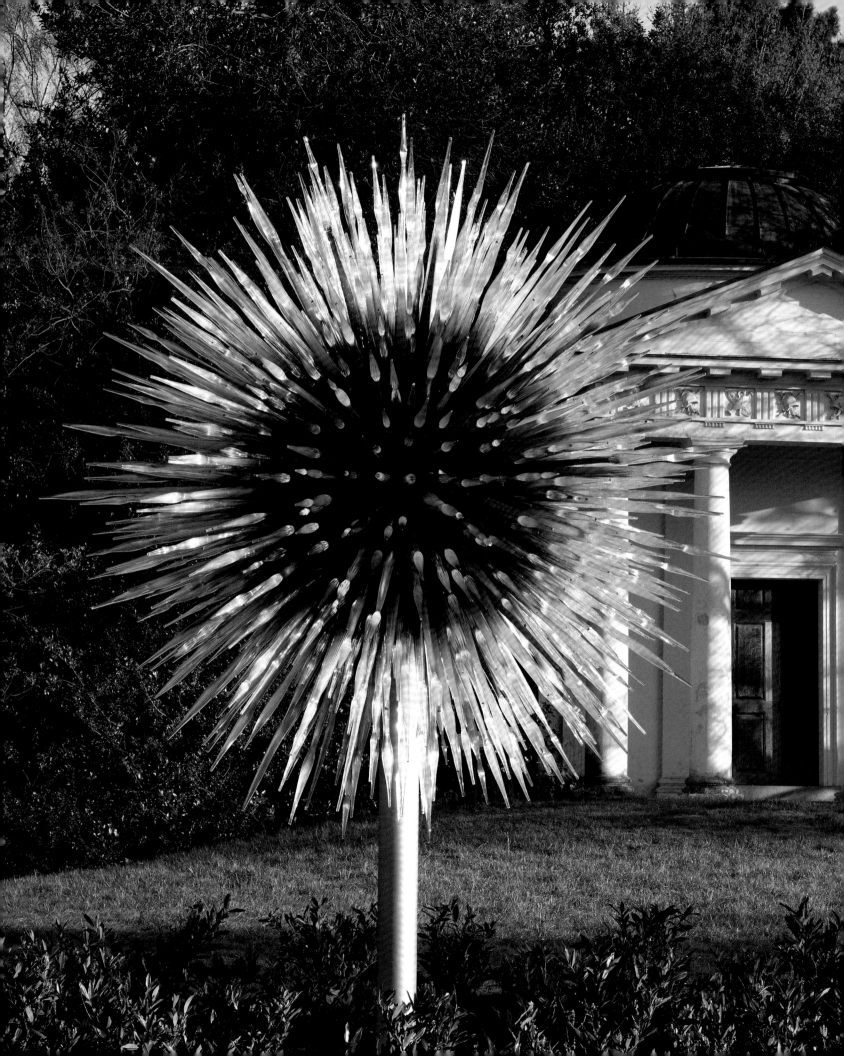

# Sapphire Star

Previous page and left:
*Sapphire Star*, 2010
Blown glass and steel
290 x 287 x 287 cm
(114 x 113 x 113")
Royal Botanic Gardens, Kew,
installed 2019

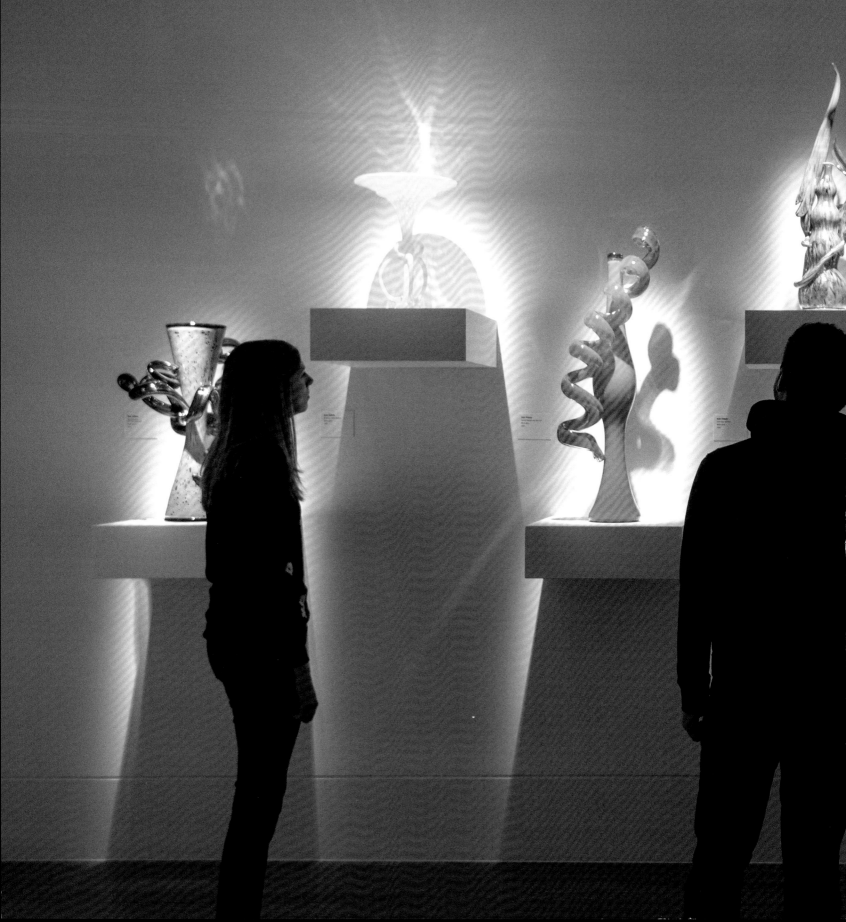

Few of Chihuly's artworks are based on specific botanical forms but instead have evolved from his engagement with colour and light. The artworks in the Shirley Sherwood Gallery bring together a selection from his series of smaller scale works including *Baskets, Cylinders* and *Macchia* through to *Persians, Seaforms* and *Rotolo*. Developed over the past 50 years, these series explore and challenge the vessel form. When seen together they give a greater insight into the evolution of Chihuly's practice.

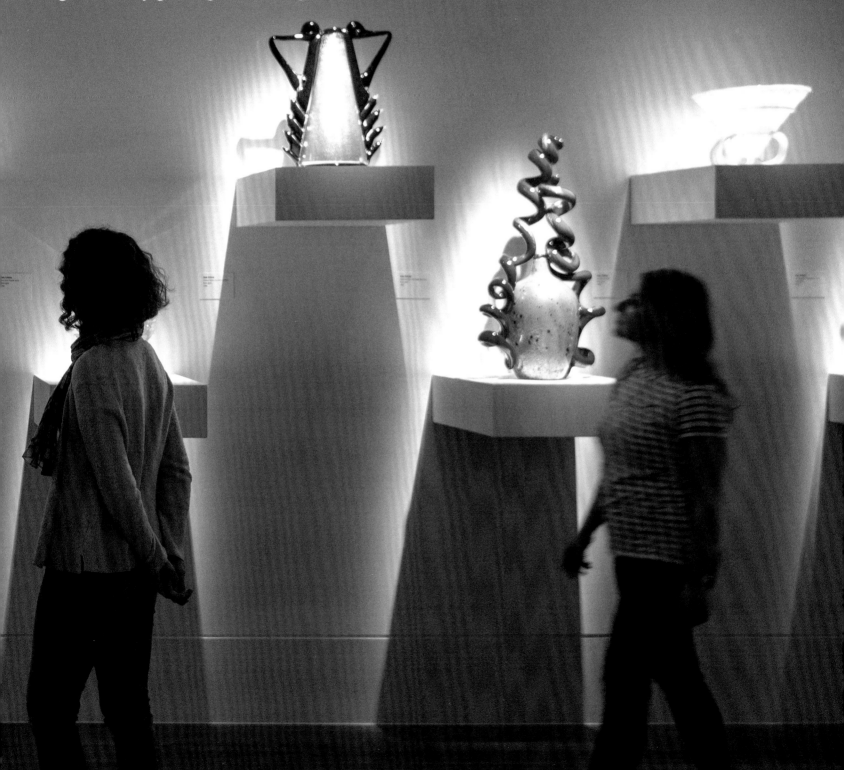

# Baskets

*'I had seen some beautiful Northwest Coast Indian baskets at the Washington State Historical Society, and I was struck by the grace of their slumped, sagging forms. I wanted to capture this grace in glass.'*

**Dale Chihuly**

Previous page:
*Venetians*
Blown glass
Royal Botanic Gardens, Kew,
installed 2019

*Celadon Basket* Grouping,
1980
Blown glass
20 x 51 x 46 cm (8 x 20 x 18")

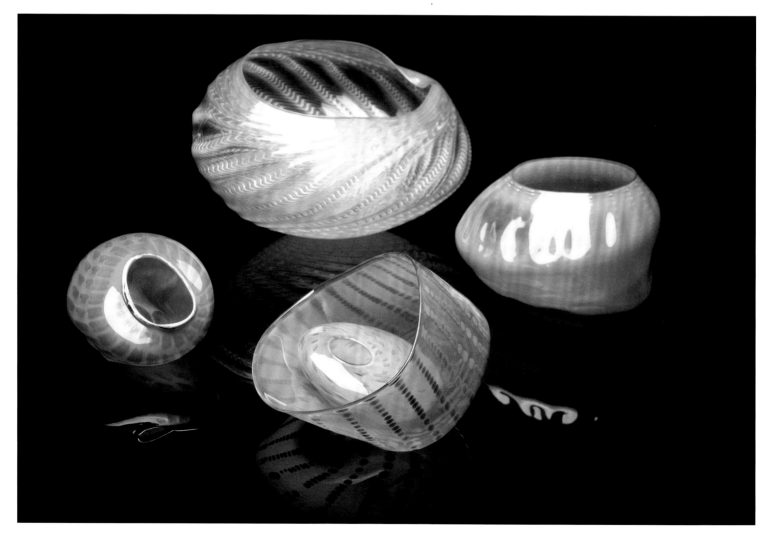

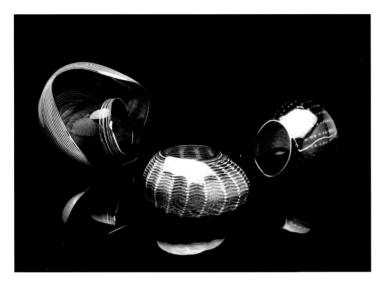

*Black Walnut Basket Quartet
with Ivory Lip Wraps*, 1981
Blown glass
23 x 64 x 36 cm (9 x 25 x 14")

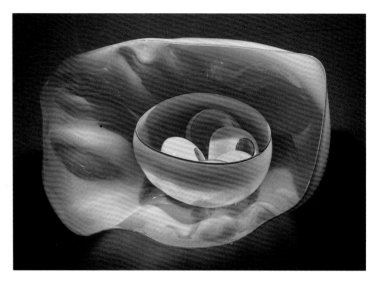

*Chrysanthemum Basket Set
with Carbon Lip Wraps*, 1993
Blown glass
36 x 56 x 43 cm (14 x 22 x 17")

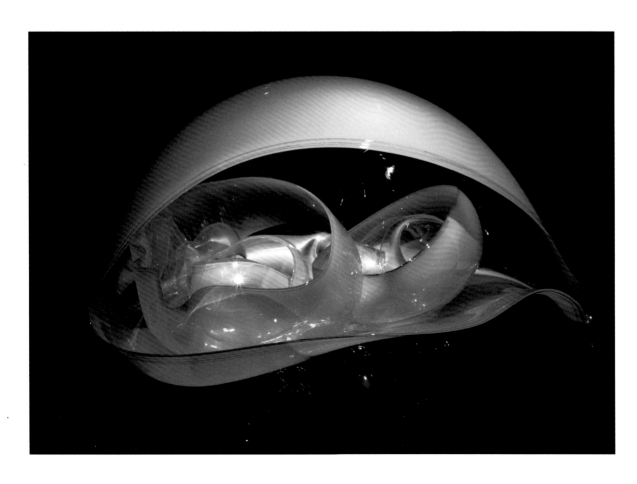

*Clear Cerulean Blue
Basket Set with Black
Lip Wraps*, 1995
Blown glass
33 x 71 x 46 cm
(13 x 28 x 18")

# Drawings

'*You can more directly sense my energy in my* Drawings *than in any other work, perhaps. And from the very beginning, the* Drawings *were done, as my glass is done, very quickly, very fast.*'

**Dale Chihuly**

*Seaform/Basket Drawing,*
1982
Mixed media on paper
76 x 56 cm (30 x 22")

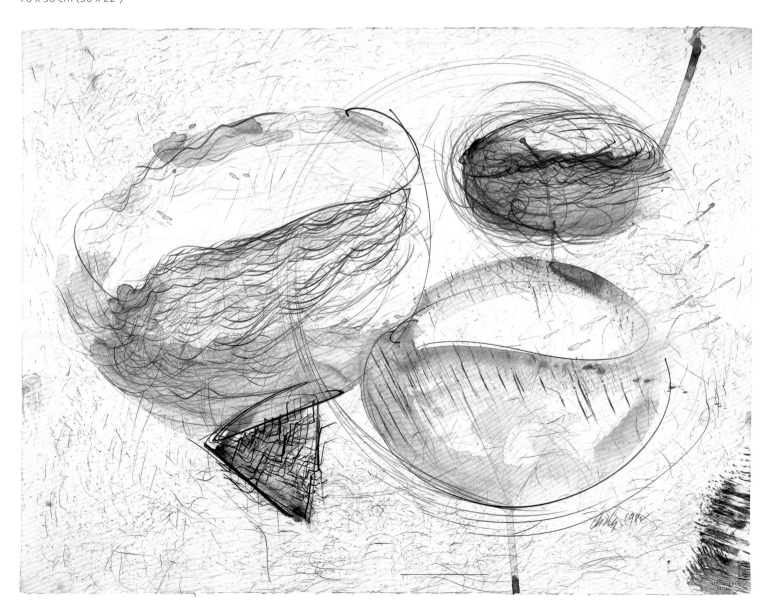

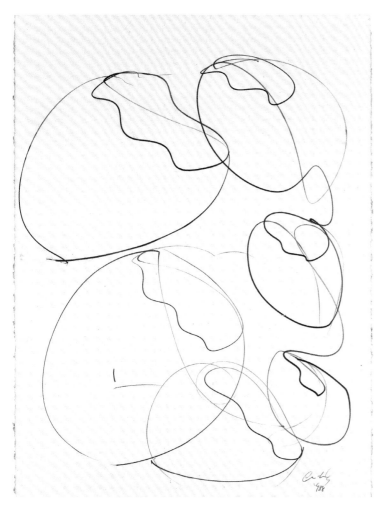
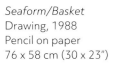

*Seaform/Basket*
Drawing, 1988
Pencil on paper
76 x 58 cm (30 x 23")

*Pencil Basket Drawing,*
1981
Pencil on paper
76 x 56 cm (30 x 22")

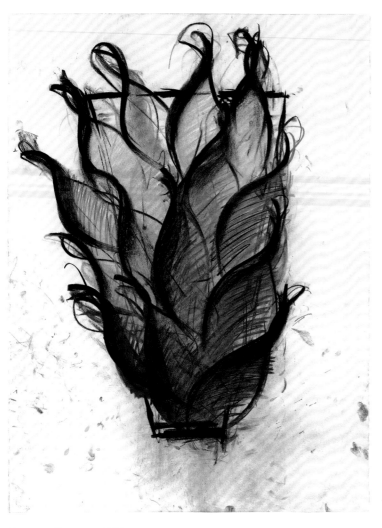

*Venetian Drawing*, 1989
Mixed media on paper
76 x 56 cm (30 x 22")

*Venetian Drawing*, 1989
Mixed media on paper
76 x 56 cm (30 x 22")

*Seaform/Basket Drawing,*
1982
Mixed media on paper
76 x 56 cm (30 x 22")

# Macchia

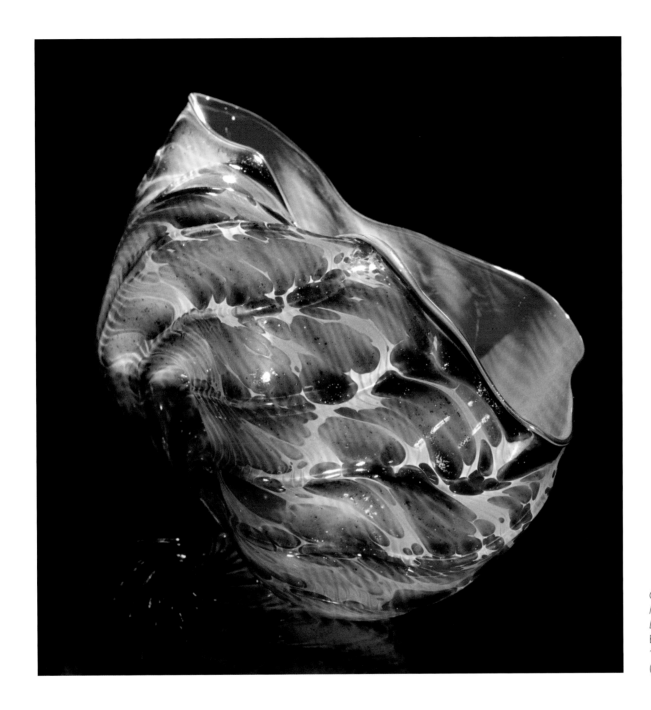

*Cadmium Orange
Macchia with Davy's Gray
Lip Wrap*, 1981
Blown glass
15 x 25 x 15 cm
(6 x 10 x 6")

*Armenian Blue Macchia
with Burnt Sienna Lip
Wrap*, 1981
Blown glass
10 x 18 x 20 cm
(4 x 7 x 8")

*'The Macchia series began with my waking up one day wanting to use all 300 of the colors in the hotshop.'*

**Dale Chihuly**

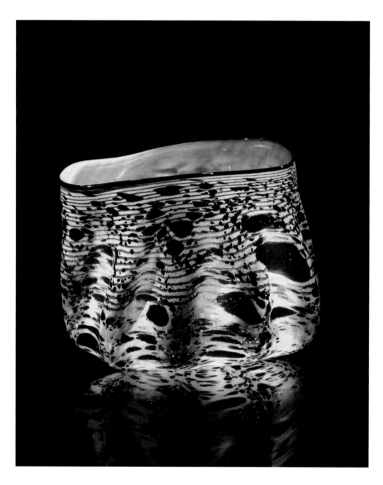

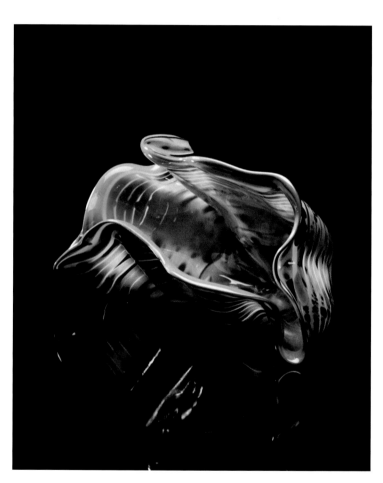

*Burnt Coral Orange Macchia
with Lava Lip Wrap*, 1982
Blown glass
20 x 33 x 25 cm
(8 x 13 x 10")

*Turquoise Green and
Yellow Macchia*, 1982
Blown glass
13 x 23 x 15 cm
(5 x 9 x 6")

*Saffron Macchia with
Russet Lip Wrap*, 1984
Blown glass
15 x 30 x 18 cm
(6 x 12 x 7")

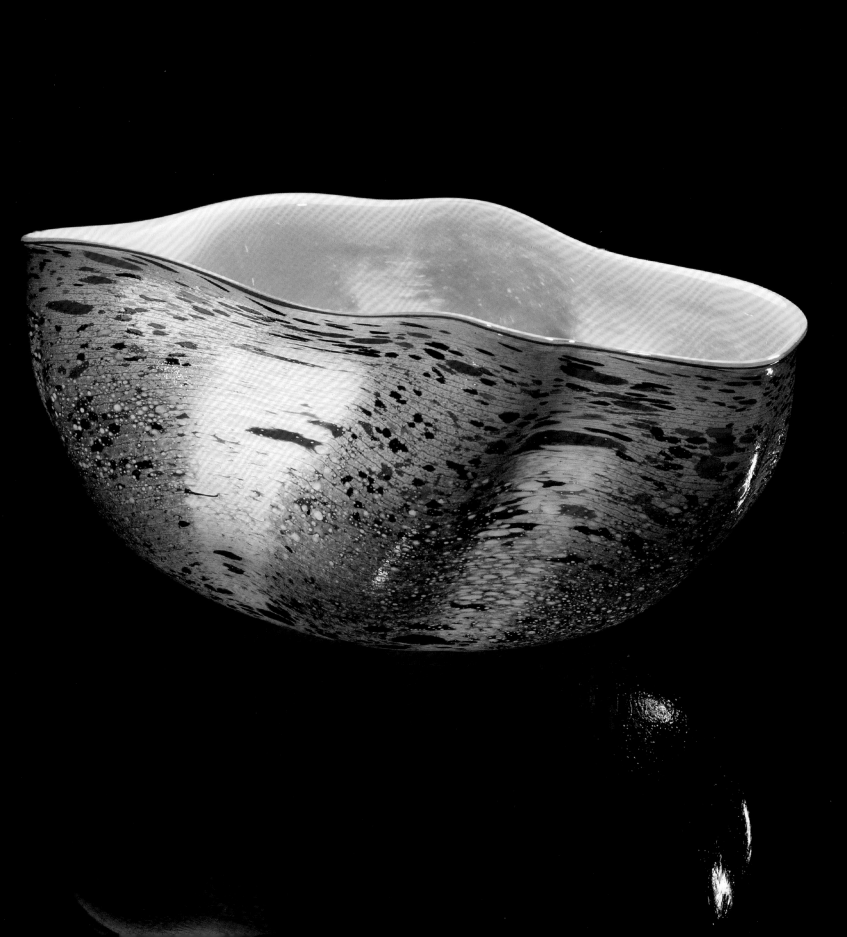

# Soft Cylinders

*'The Soft Cylinders are the offspring of two earlier series.
They express the same asymmetry and movement of the Baskets
while incorporating the pick-up drawings of the Cylinders.'*

**Dale Chihuly**

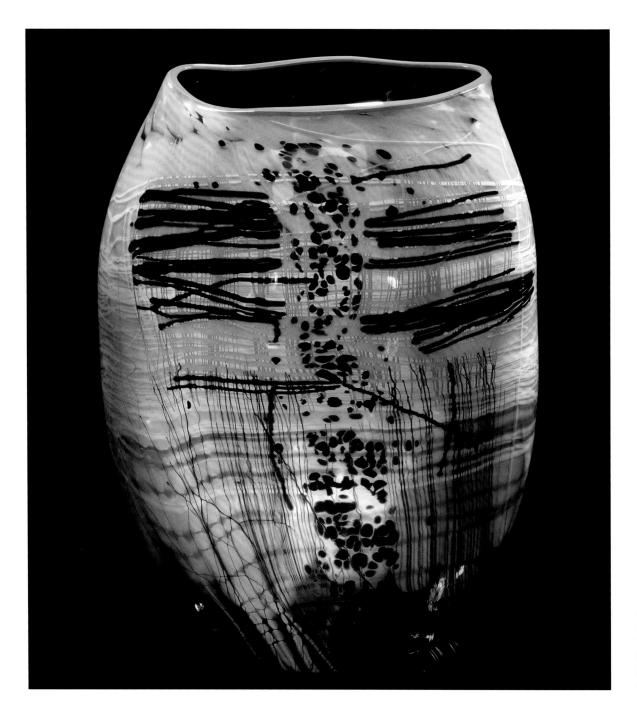

*Eggplant Soft Cylinder
with Lush Green Lip
Wraps*, 2002
Blown glass
51 x 36 x 33 cm
(20 x 14 x 13")

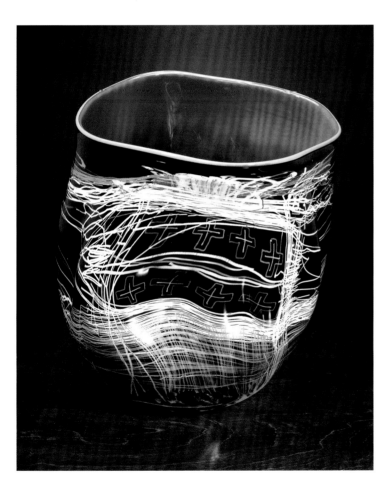

*Black Orange Soft Cylinder*
*with Lime Lip Wrap*, 2006
Blown glass
53 x 46 x 23 cm
(21 x 18 x 19")

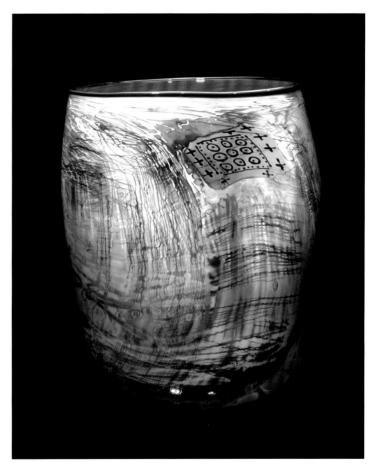

*Scarlet Soft Cylinder with*
*Deep Green Lip Wrap*,
1990
Blown glass
36 x 33 x 30 cm
(14 x 13 x 12")

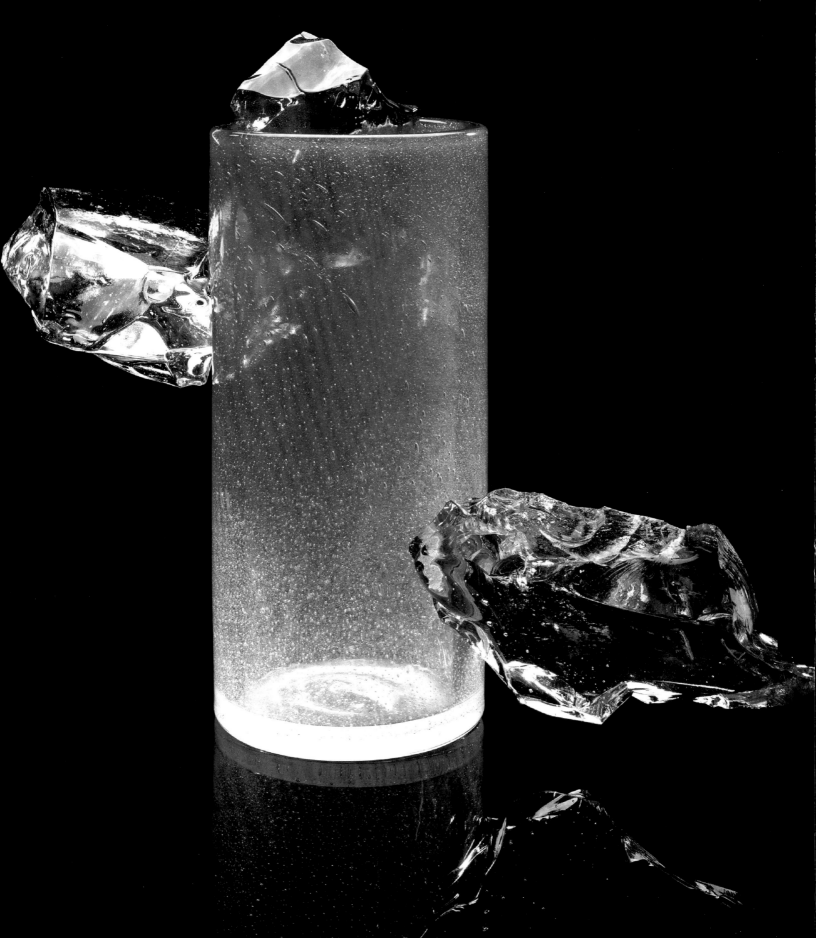

Jerusalem Cylinders

# Rotolo

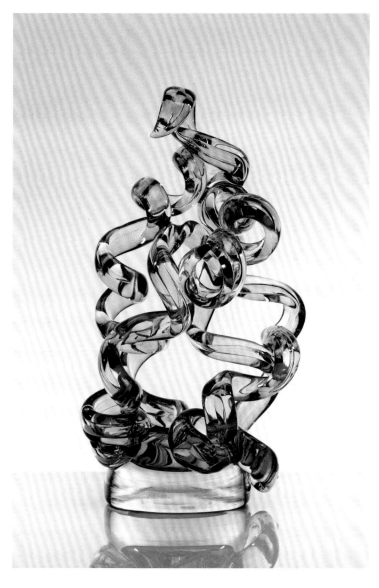

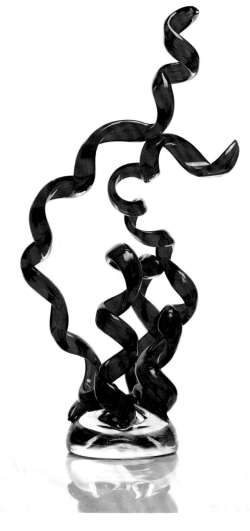

*Rotolo 79*, 2018
Blown glass
76 x 43 x 43 cm
(30 x 17 x 17")

*Rotolo 81*, 2018
Blown glass
112 x 53 x 41 cm
(44 x 21 x 16")

*Jerusalem 2000*
*Cylinder #42*, 1999
Blown glass
46 x 64 x 25 cm
(18 x 25 x 10")

# Ikebana

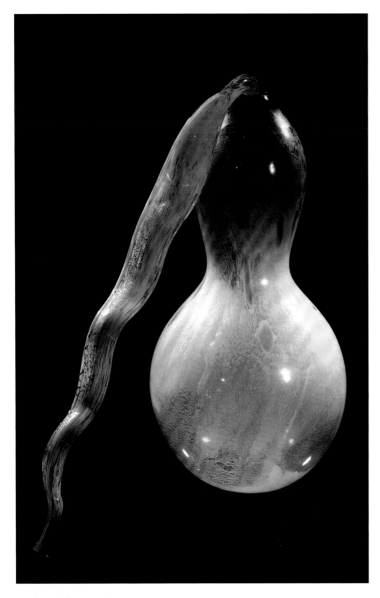

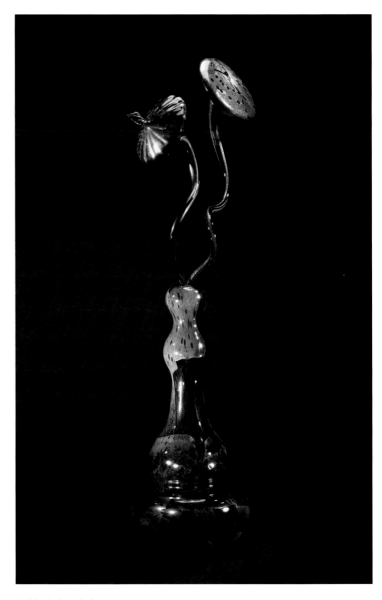

*Amber Ikebana with
Gold Stem*, 1992
Blown glass
86 x 81 x 43 cm
(34 x 32 x 17")

*Gilded Blue Ikebana
with Cobalt and Violet
Stems*, 1999
Blown glass
165 x 53 x 38 cm
(65 x 21 x 15")

*'These are some of the biggest pieces we make. They are about
4 or 5 feet tall and have very simple vases, usually in bright colors,
and stems that are made separately... That's what allows us to make
the Ikebana larger and allows us to put more details into the parts.'*

**Dale Chihuly**

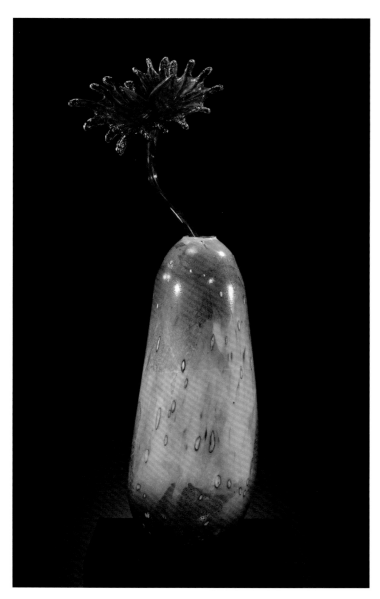

*Golden Ikebana with
Topaz Frog Foot Stem,*
1991
Blown glass
137 x 51 x 38 cm
(54 x 20 x 15")

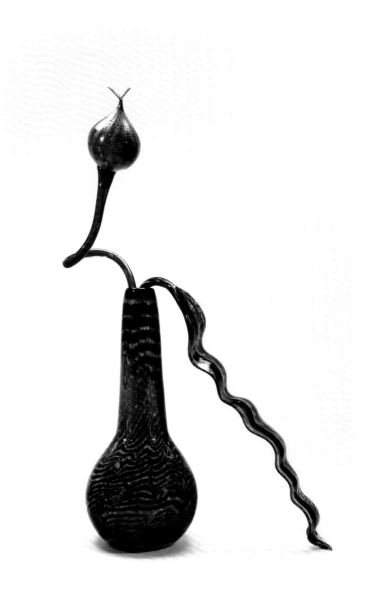

*Tiger Striped Ikebana
with Cobalt Stem and
Russet Leaf,* 1992
Blown glass
145 x 81 x 38 cm
(57 x 32 x 15")

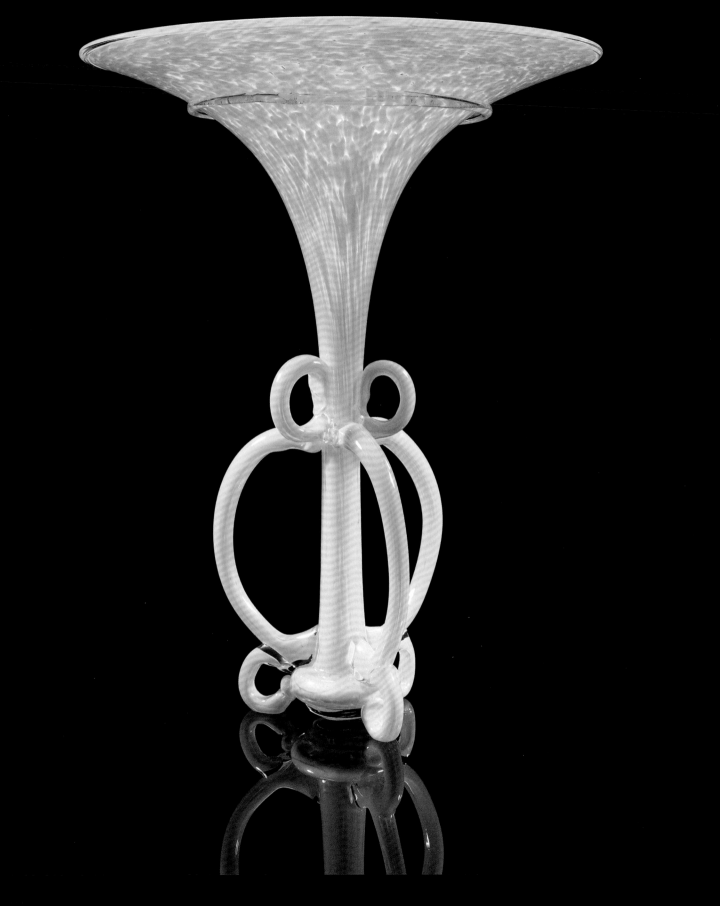

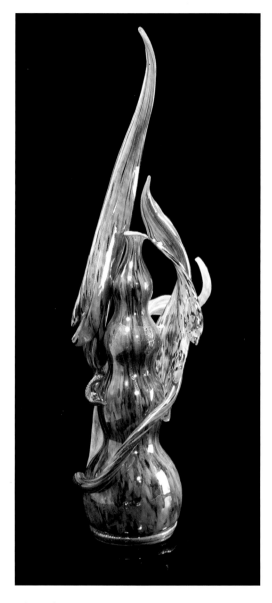

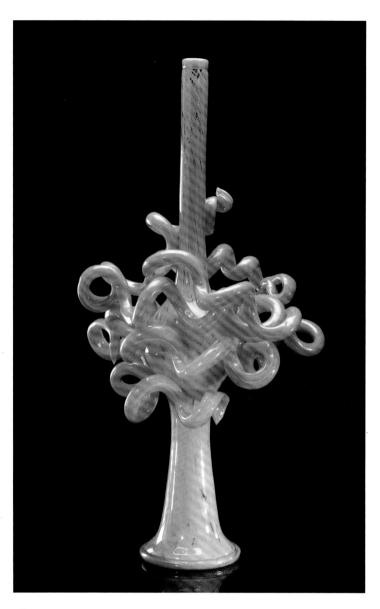

*Silver Blue Venetian,*
1990
Blown glass
81 x 25 x 23 cm
(32 x 10 x 9")

*Chrome Orange Venetian
with Coils,* 1990
Blown glass
91 x 48 x 43 cm
(36 x 19 x 17")

*Cadmium Yellow
Venetian,* 1991
Blown glass
43 x 33 x 33 cm
(17 x 13 x 13")

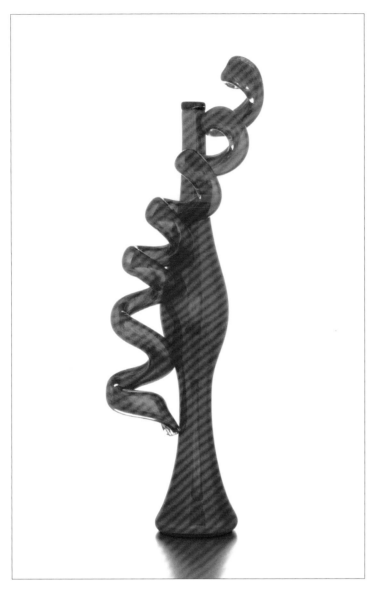

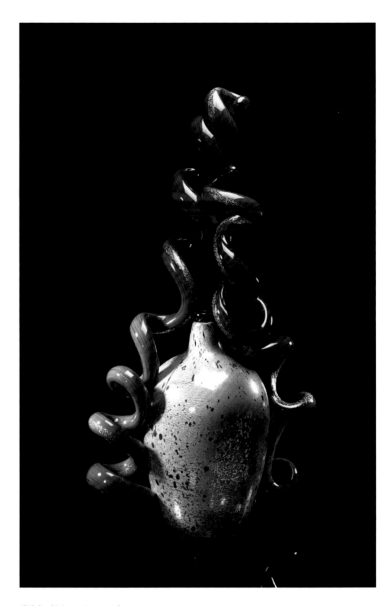

*Scarlet Venetian with*
*One Coil,* 1991
Blown glass
76 x 33 x 25 cm
(30 x 13 x 10")

*Gilded Venetian with*
*Cobalt Blue Coils,* 1992
Blown glass
81 x 48 x 25 cm
(32 x 19 x 10")

*Terre Verte Venetian*
*#203*, 1988
Blown glass
46 x 30 x 30 cm
(18 x 12 x 12")

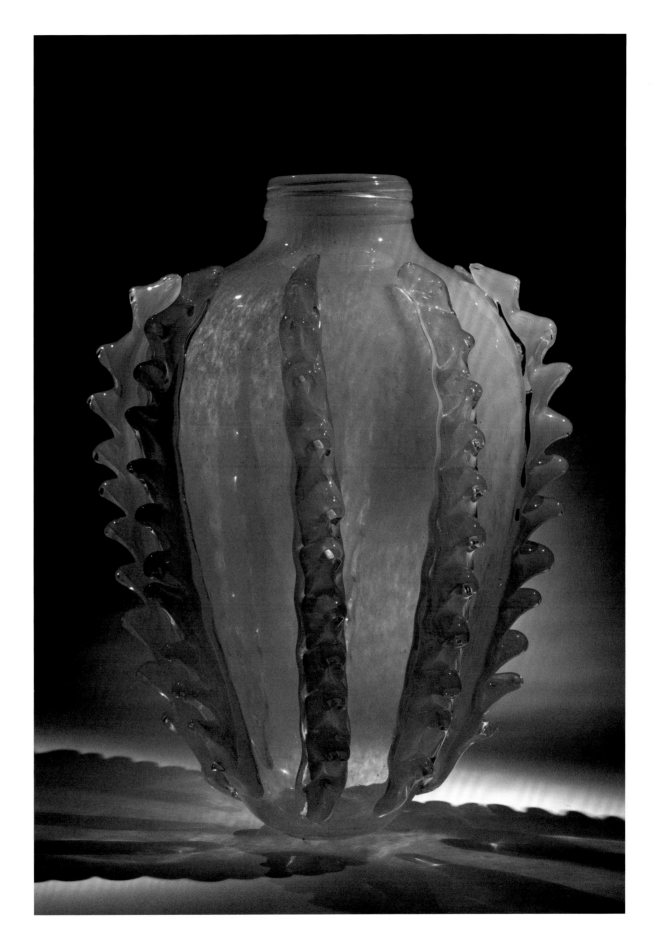

# Seaforms

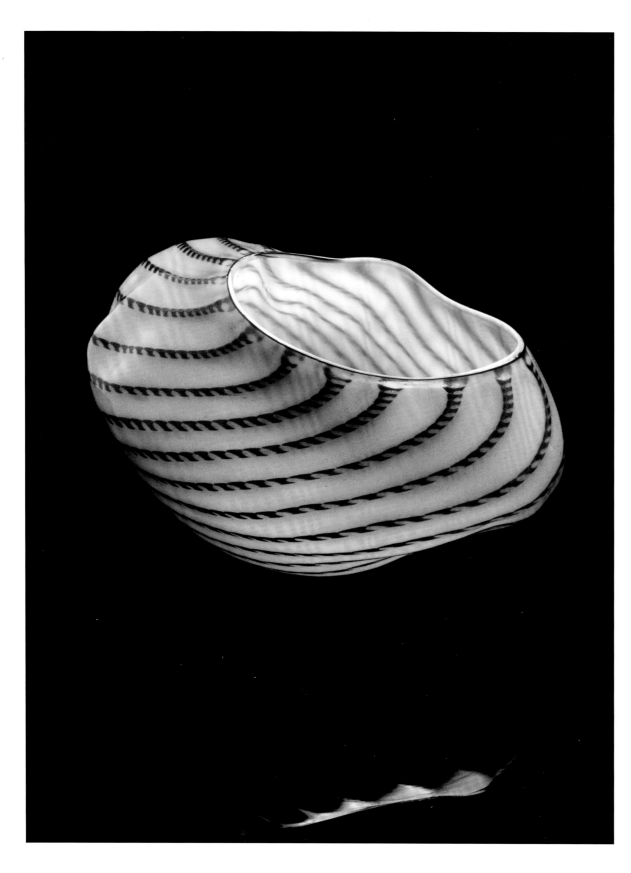

*Naples Yellow Seaform with Sepia Lip Wrap,* 1980
Blown glass
18 x 28 x 20 cm
(7 x 11 x 8")

*'With* Baskets or Seaforms, *my concern was with the form and developing ways to work with fire, gravity and centrifugal force – to stretch and blow the glass to its edge. With the* Seaforms *came the use of the ribbed optical molds, which added strength, allowing us to blow even thinner.'*

**Dale Chihuly**

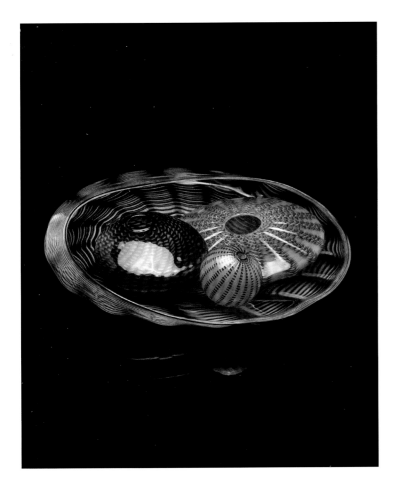

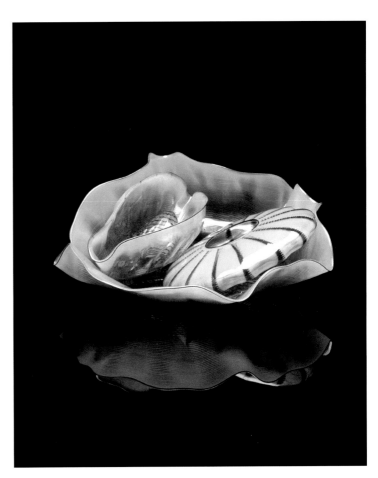

*Pink Striped Seaform
Set with Black Lip
Wraps,* 1981
Blown glass
13 x 46 x 43 cm
(5 x 18 x 17")

*Tea Green Seaform
Set with Mars Black Lip
Wraps,* 1983
Blown glass
20 x 51 x 51 cm
(8 x 20 x 20")

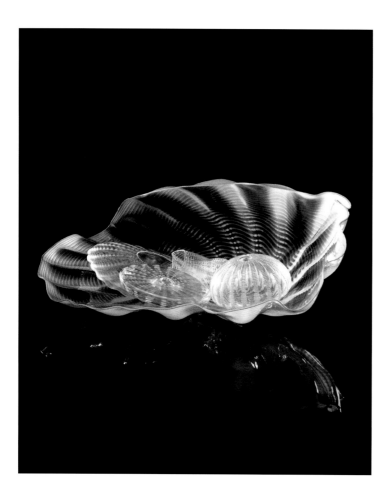

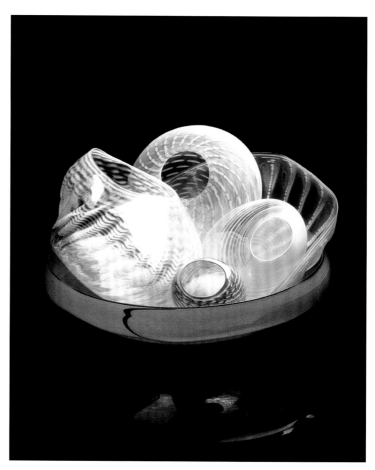

*Pink Seaform Set with*
*White Lip Wraps*, 1988
Blown glass
18 x 38 x 51 cm
(7 x 15 x 20")

*Pink and White Seaform*
*Set*, 1980
Blown glass
23 x 43 x 43 cm
(9 x 17 x 17")

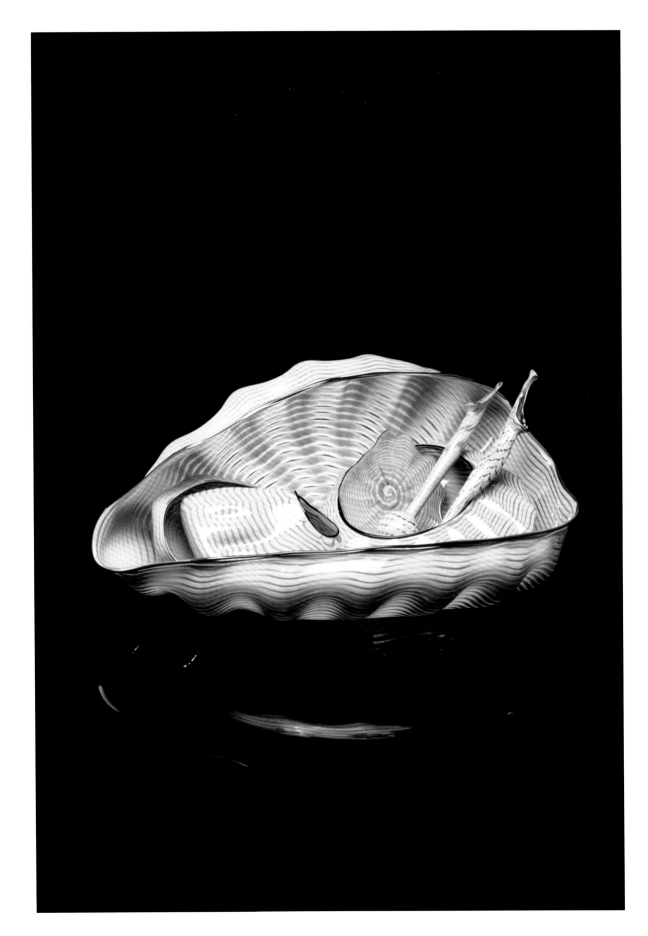

*Goldenrod Striped
Seaform Set with
Sapphire and Onyx Lip
Wraps*, 1989
Blown glass
25 x 61 x 33 cm
(10 x 24 x 13")

# Cylinders

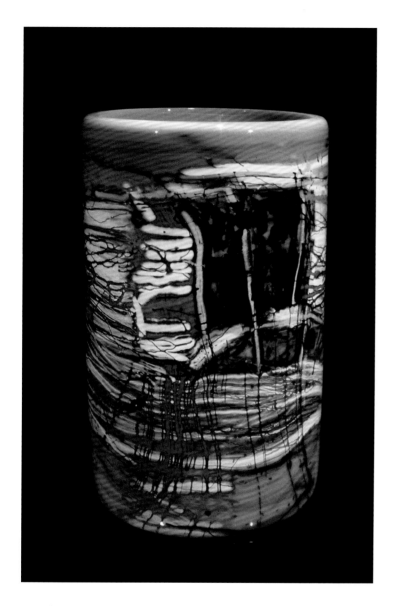

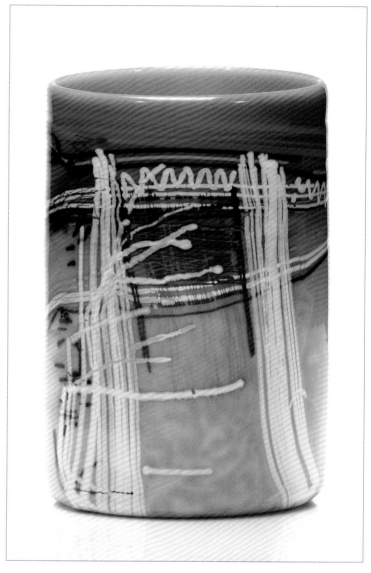

*Peach Cylinder with Indian
Blanket Drawing*, 1995
Blown glass
30 x 18 x 18 cm
(12 x 7 x 7")

*Peach Cylinder with Indian
Blanket Drawing*, 1995
Blown glass
20 x 13 x 13 cm
(8 x 5 x 5")

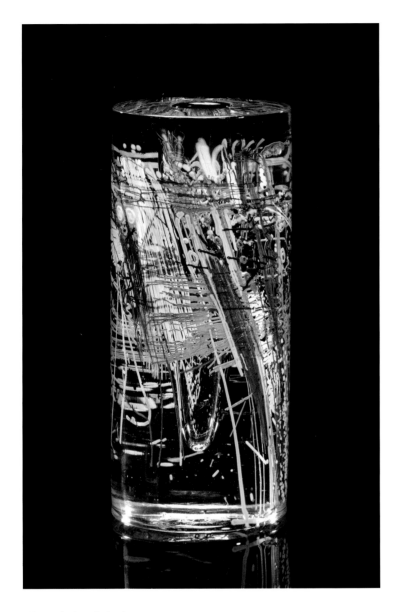

*Clear Blanket Cylinder,*
2015
Blown glass
33 x 15 x 15 cm
(13 x 6 x 6")

*Clear Blanket Cylinder*
(detail)

*'We came up with this technique where we'd lay out little bits of glass on the steel table to create a pattern or drawing, and then pick it up with molten glass, and then blow that glass into a form.'*

**Dale Chihuly**

# Persians

*'The Persians started out as a search for forms. We worked for a year on doing only experimental* Persians… *we made at least a thousand or more.'*

**Dale Chihuly**

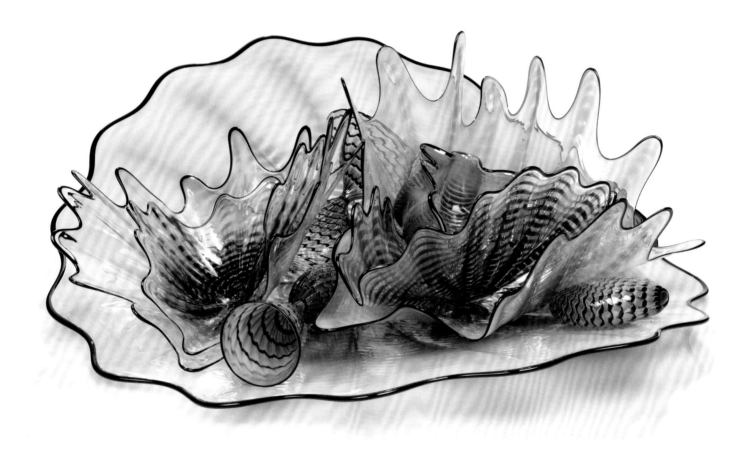

Neopolitan Yellow Persian
Set with Onyx Lip Wraps,
1994
Blown glass
25 x 61 x 61 cm
(10 x 24 x 24")

Cinnamon and Cream
Persian with Chocolate Lip
Wrap, 1988
Blown glass
18 x 38 x 33 cm
(7 x 15 x 13")

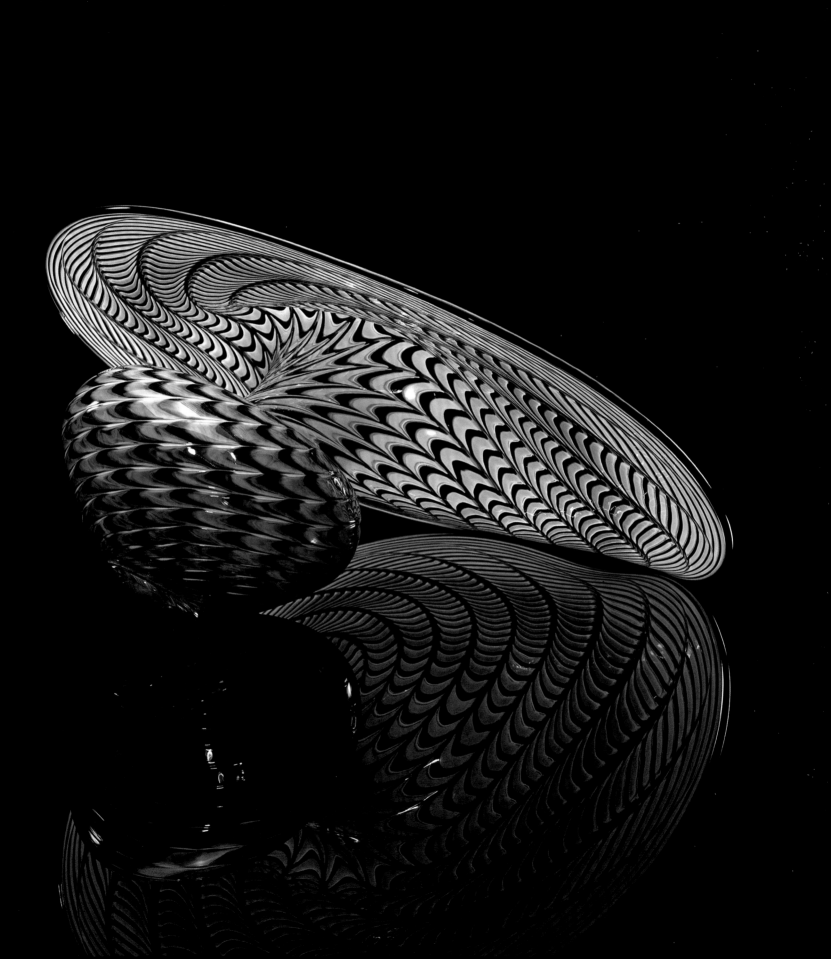

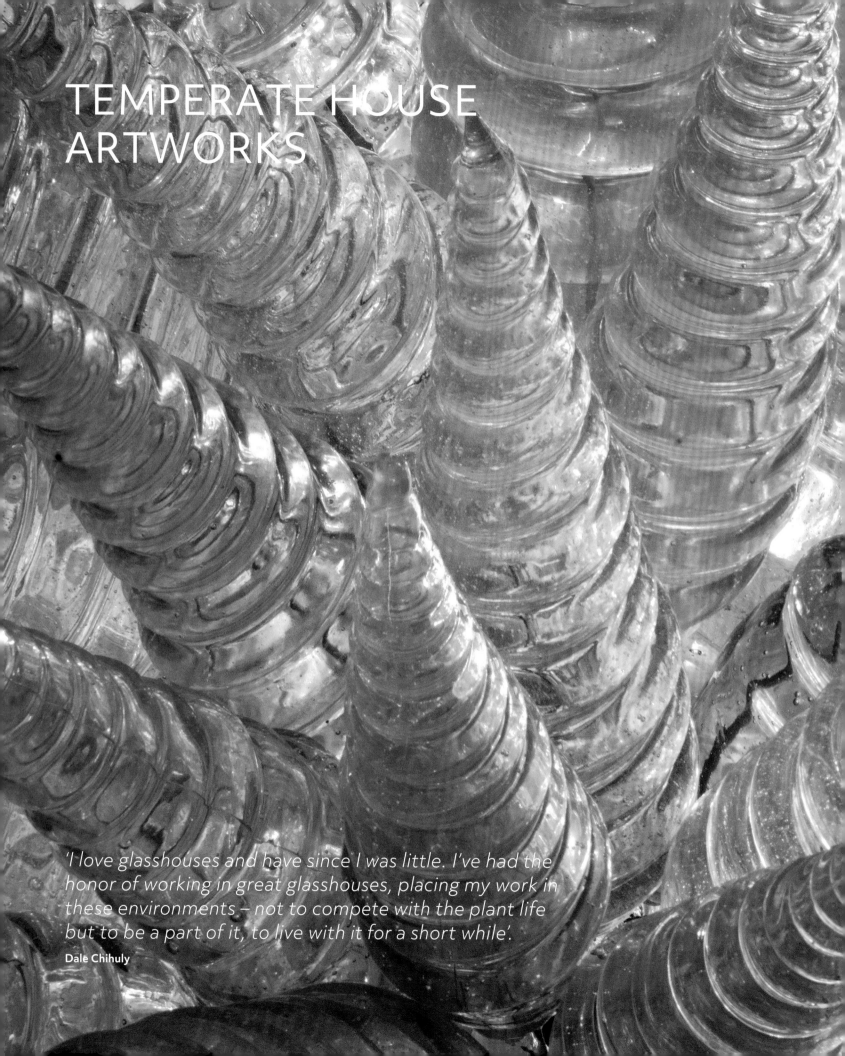

# TEMPERATE HOUSE ARTWORKS

*'I love glasshouses and have since I was little. I've had the honor of working in great glasshouses, placing my work in these environments – not to compete with the plant life but to be a part of it, to live with it for a short while'.*

**Dale Chihuly**

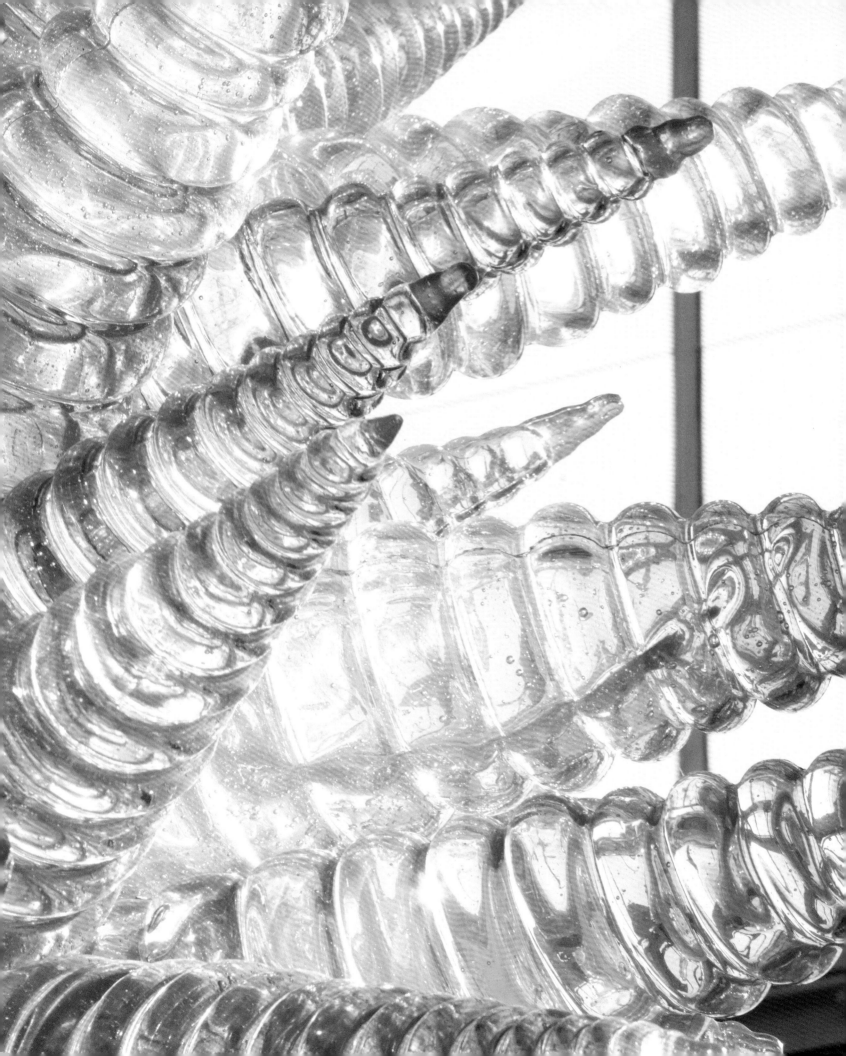

# Opal and Gold Chandelier

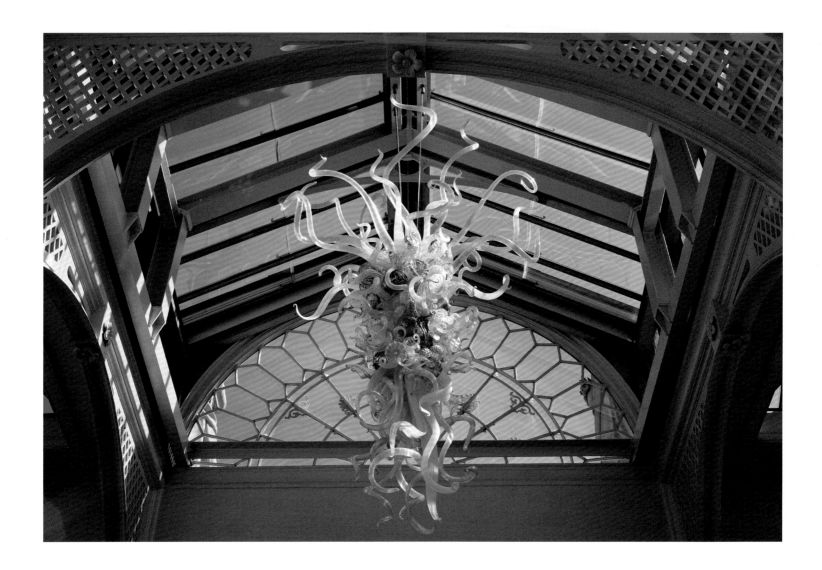

Previous page:
*Chartreuse Hornet Polyvitro*
*Chandelier* (detail), 2001
Polyvitro and steel
226 x 178 x 175 cm
(89 x 70 x 69")
Royal Botanic Gardens, Kew,
installed 2019

*Opal and Gold Chandelier*, 2010
Blown glass and steel
254 x 173 x 175 cm
(100 x 68 x 69")
Royal Botanic Gardens, Kew,
installed 2019

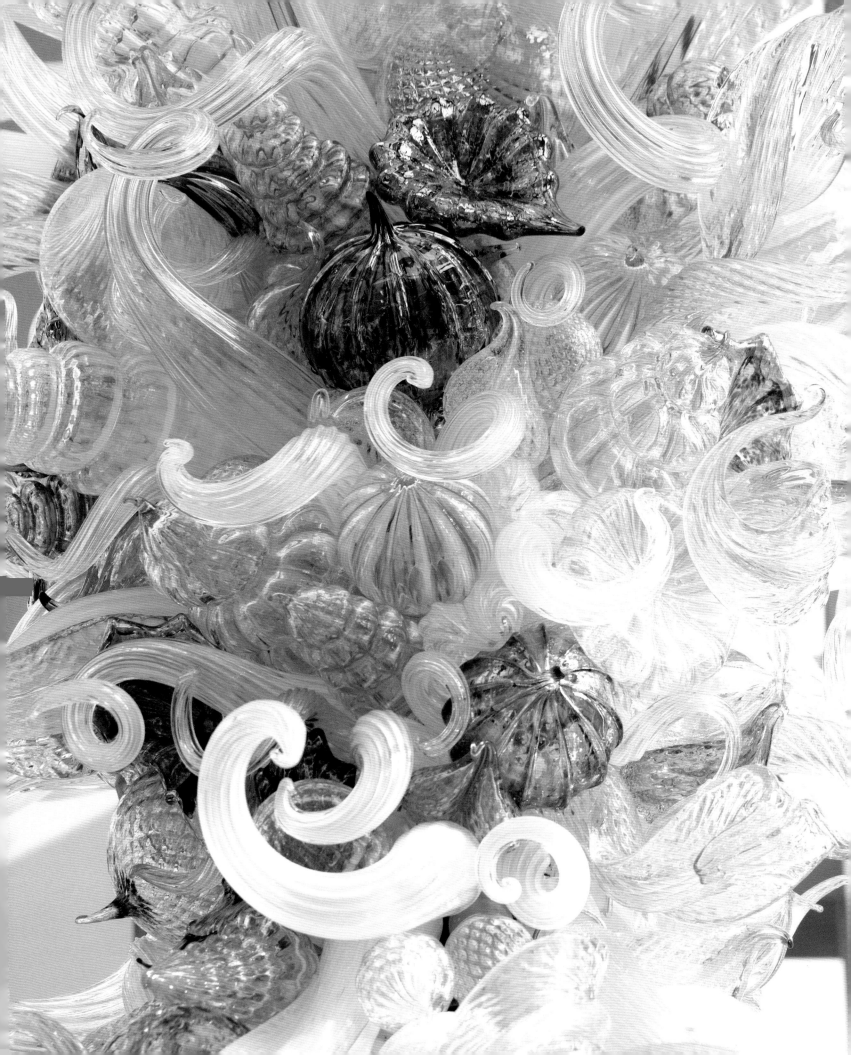

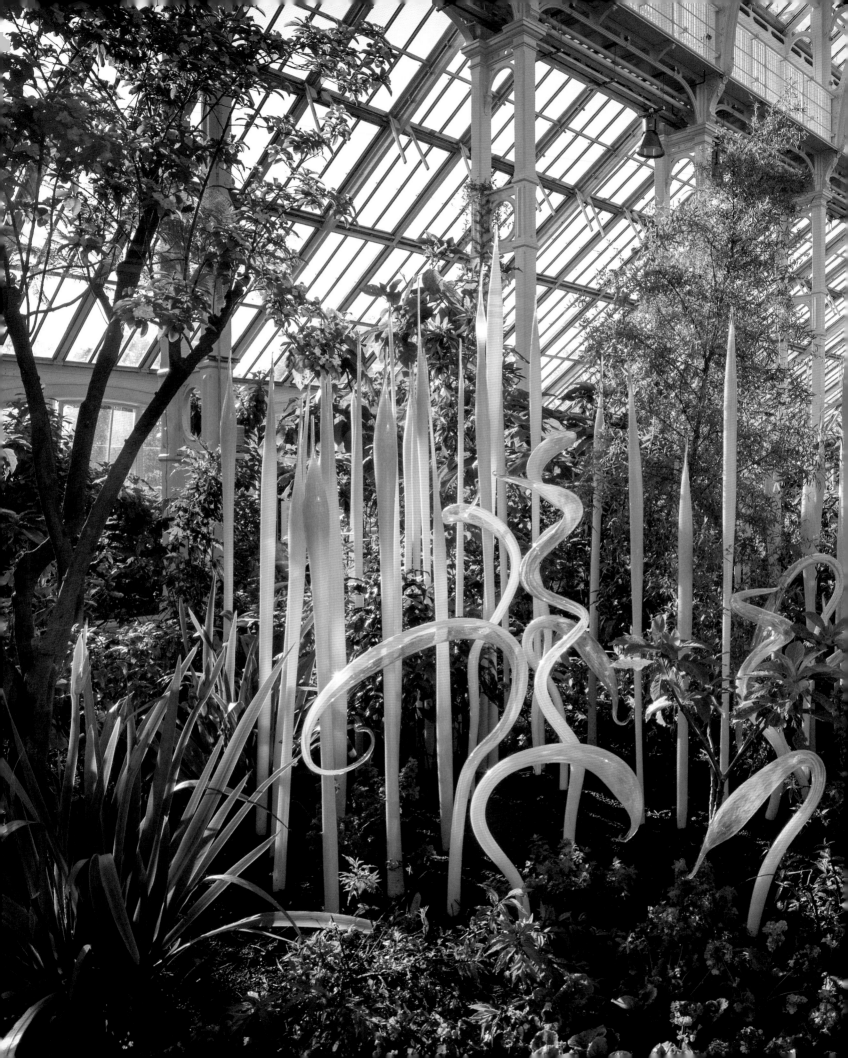

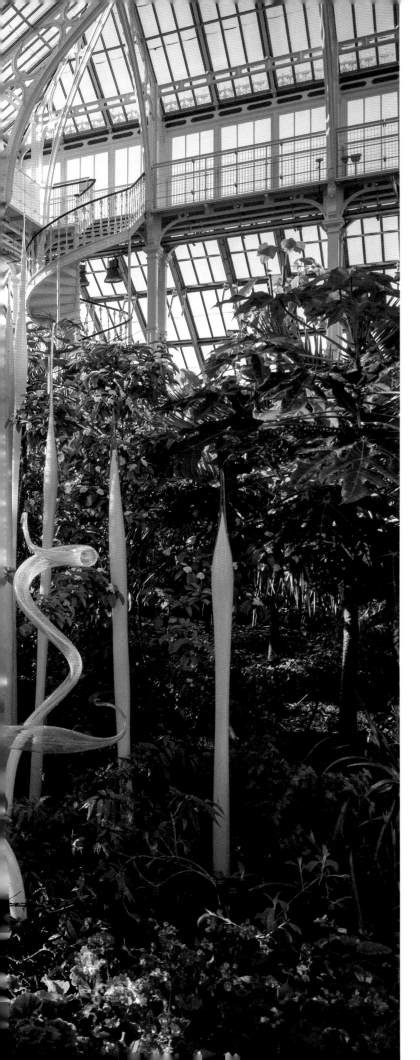

# Yellow Herons and Reeds

*Yellow Herons and Reeds*,
Blown glass
Royal Botanic Gardens, Kew,
installed 2019

# Chartreuse Hornet
# Polyvitro Chandelier

*Chartreuse Hornet*
*Polyvitro Chandelier*, 2001
Polyvitro and steel
226 x 178 x 175 cm
(89 x 70 x 69")
Royal Botanic Gardens, Kew,
installed 2019

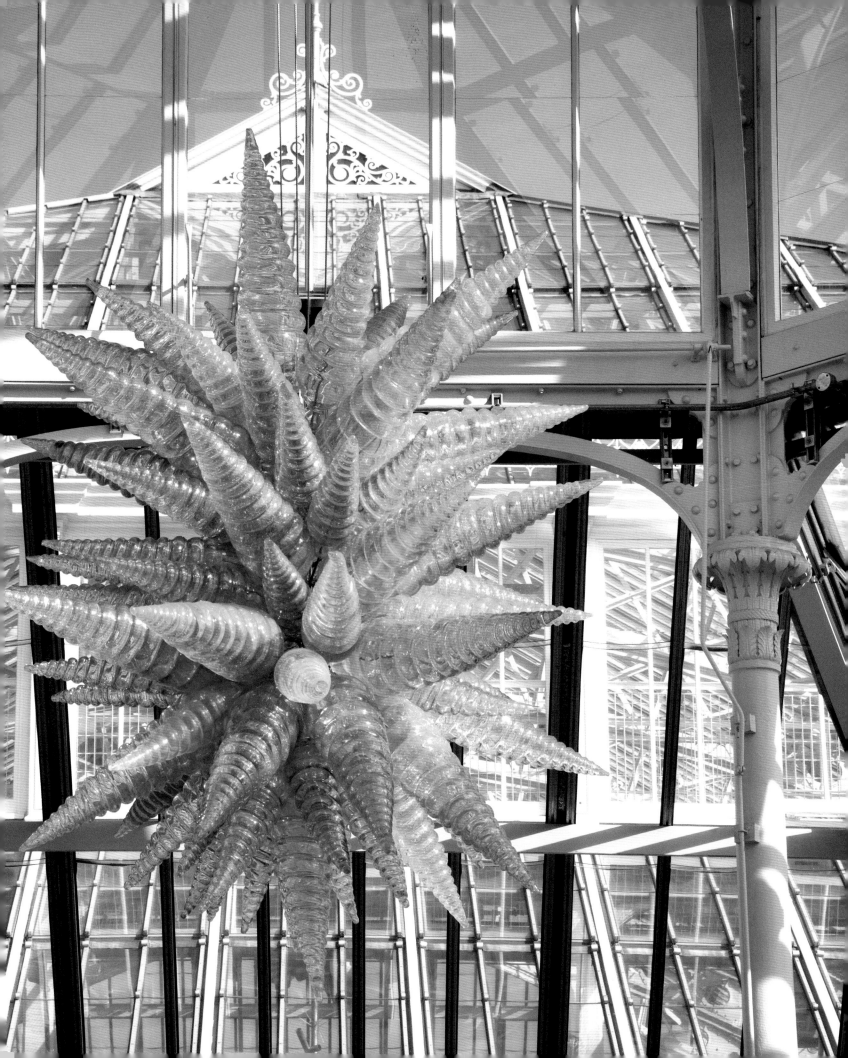

# Ikebana

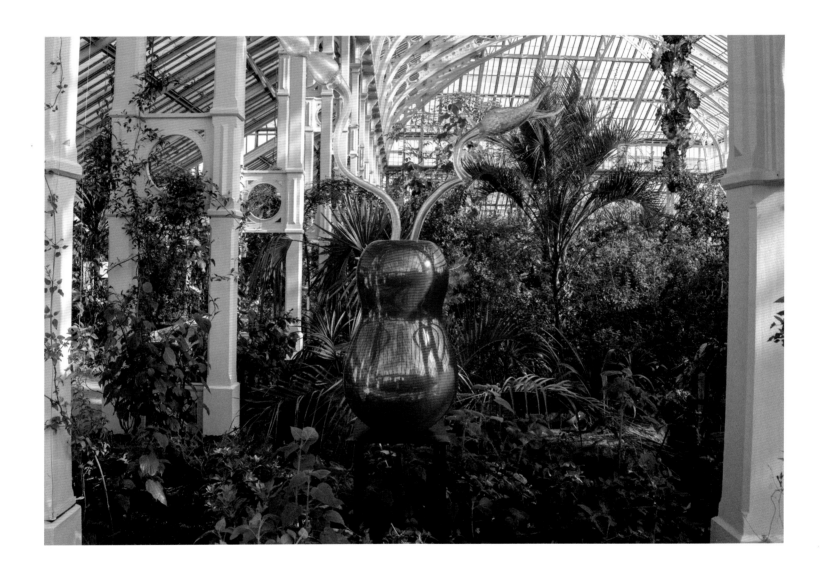

*Ikebana*
Blown glass
Royal Botanic Gardens, Kew,
installed 2019

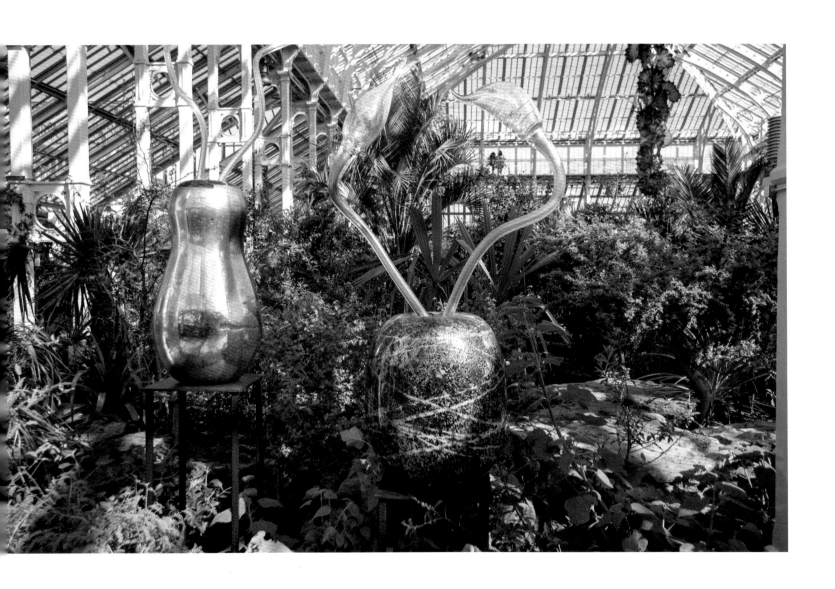

*Ikebana*
Blown glass
Royal Botanic Gardens, Kew,
installed 2019

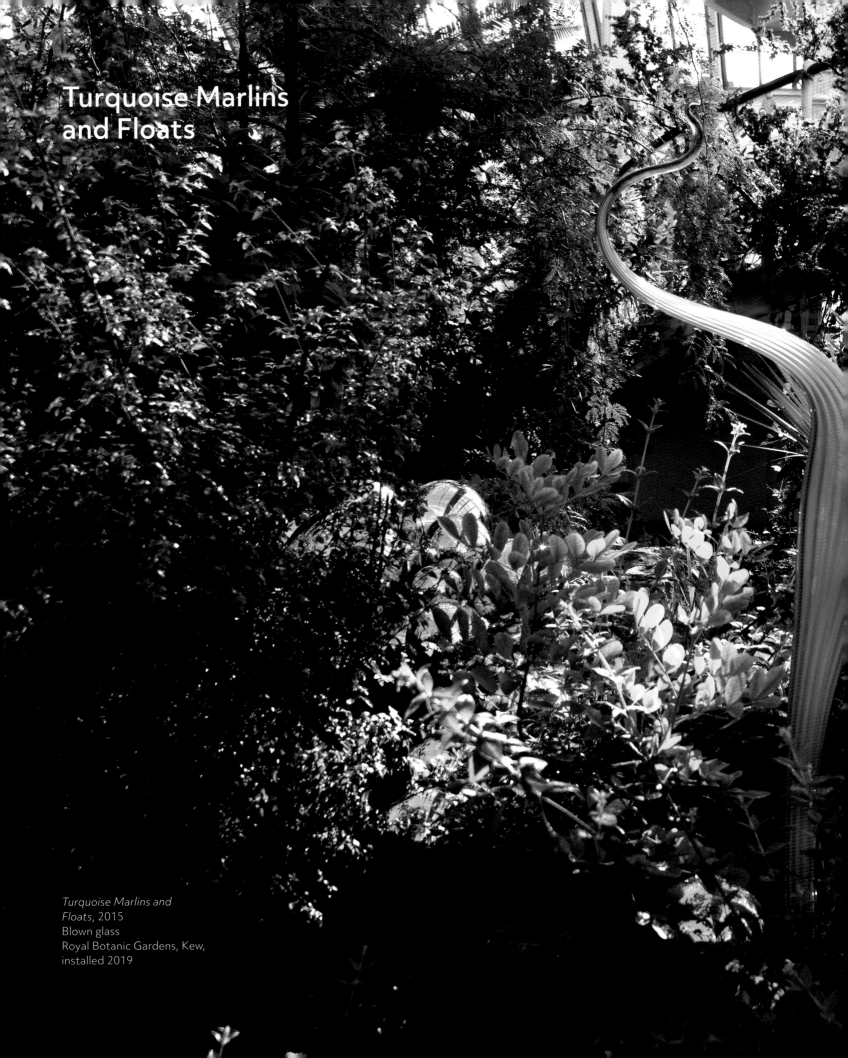

Turquoise Marlins
and Floats

*Turquoise Marlins and*
*Floats*, 2015
Blown glass
Royal Botanic Gardens, Kew,
installed 2019

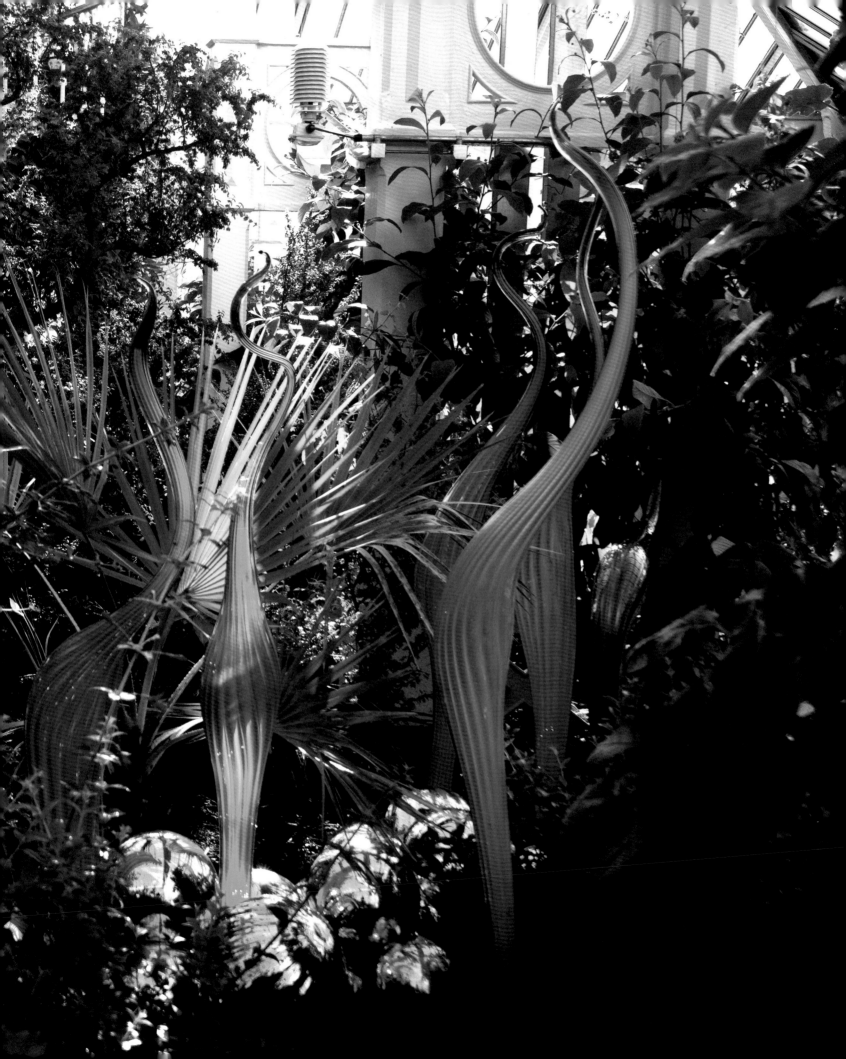

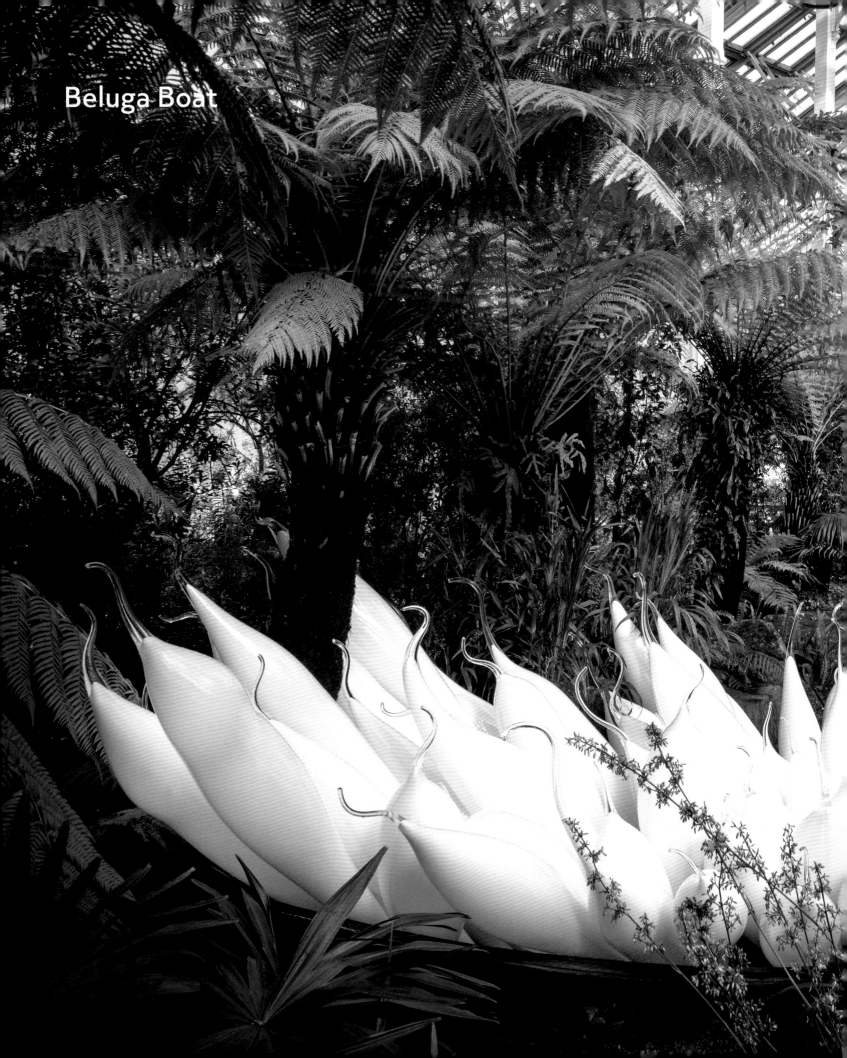

Beluga Boat

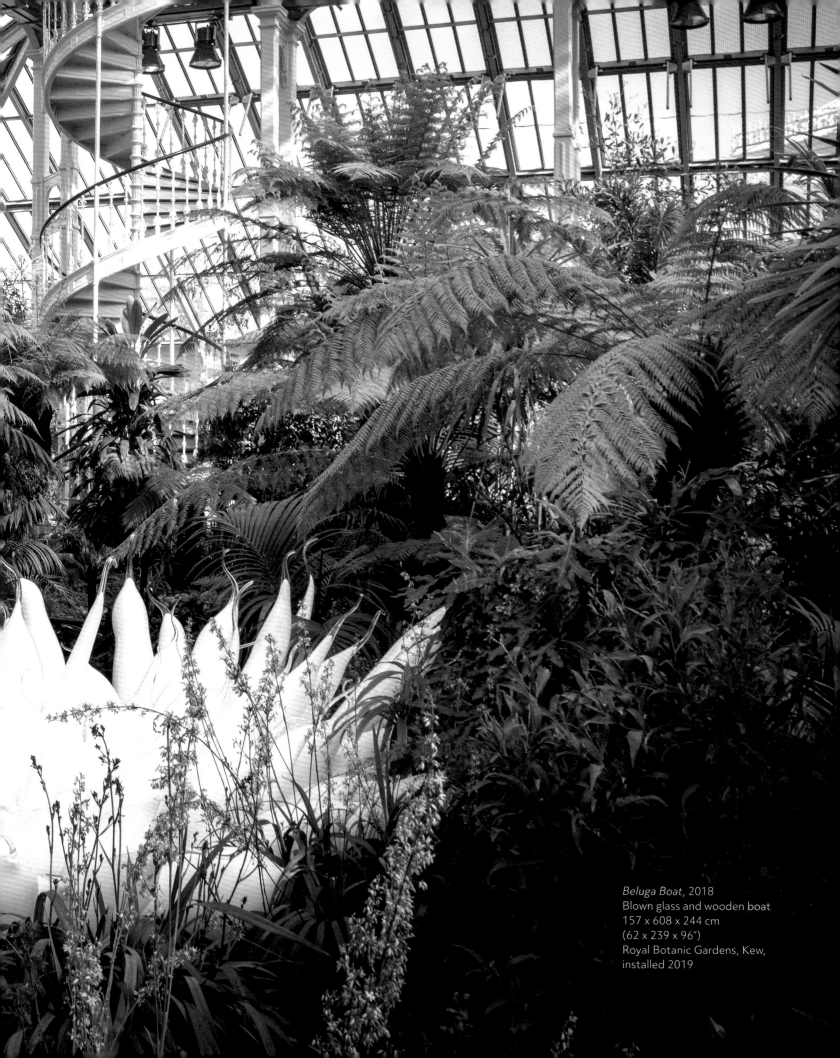

*Beluga Boat*, 2018
Blown glass and wooden boat
157 x 608 x 244 cm
(62 x 239 x 96")
Royal Botanic Gardens, Kew,
installed 2019

# Temperate House Persians

*Temperate House Persians*
(detail), 2018
Blown glass and steel
996 x 239 x 213 cm
(392 x 94 x 84")
Royal Botanic Gardens, Kew,
installed 2019

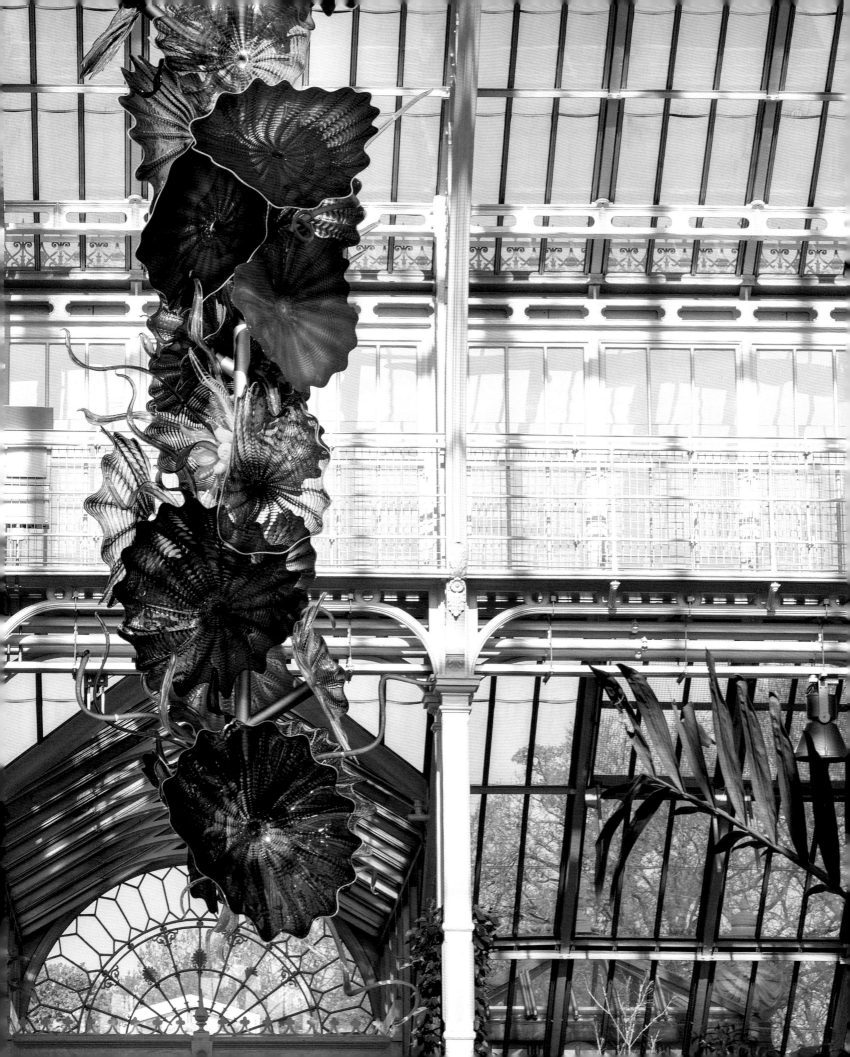

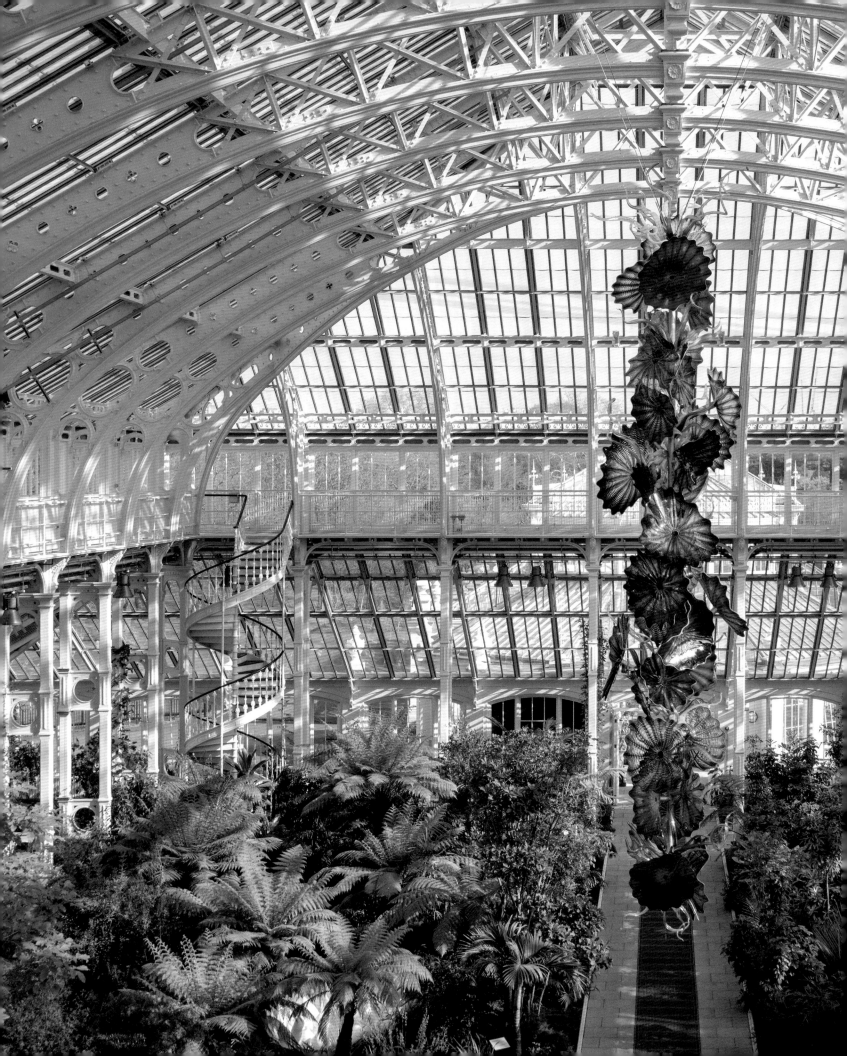

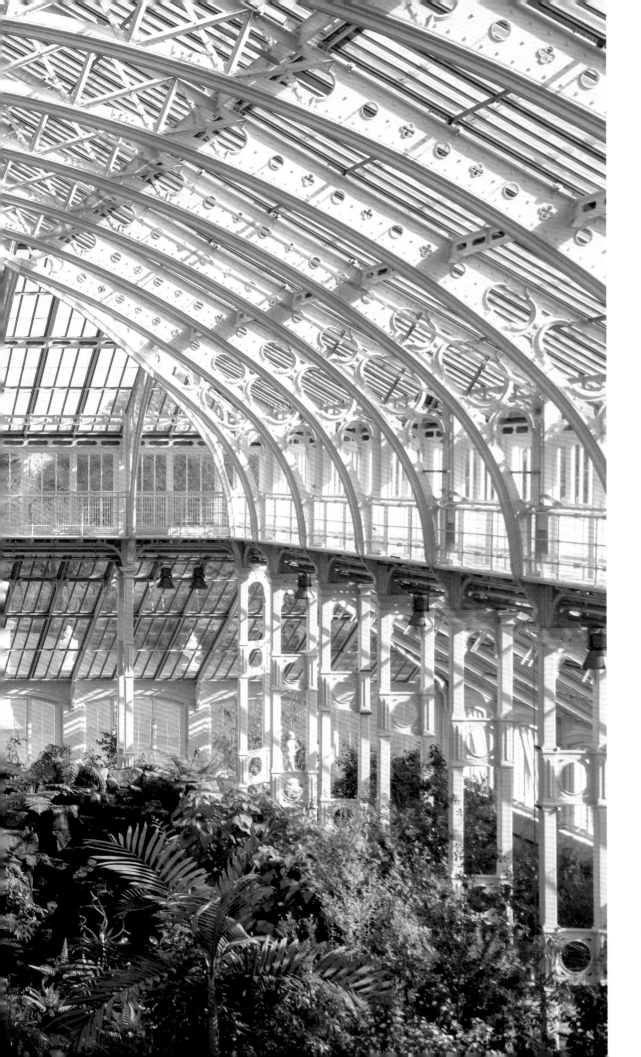

*Temperate House Persians,*
2018
Blown glass and steel
996 x 239 x 213 cm
(392 x 94 x 84")
Royal Botanic Gardens, Kew,
installed 2019

# Hebron Vessels

*Hebron Vessels*, 1999
Blown glass
91 x 732 x 218 cm
(36 x 288 x 86")
Royal Botanic Gardens, Kew,
installed 2019

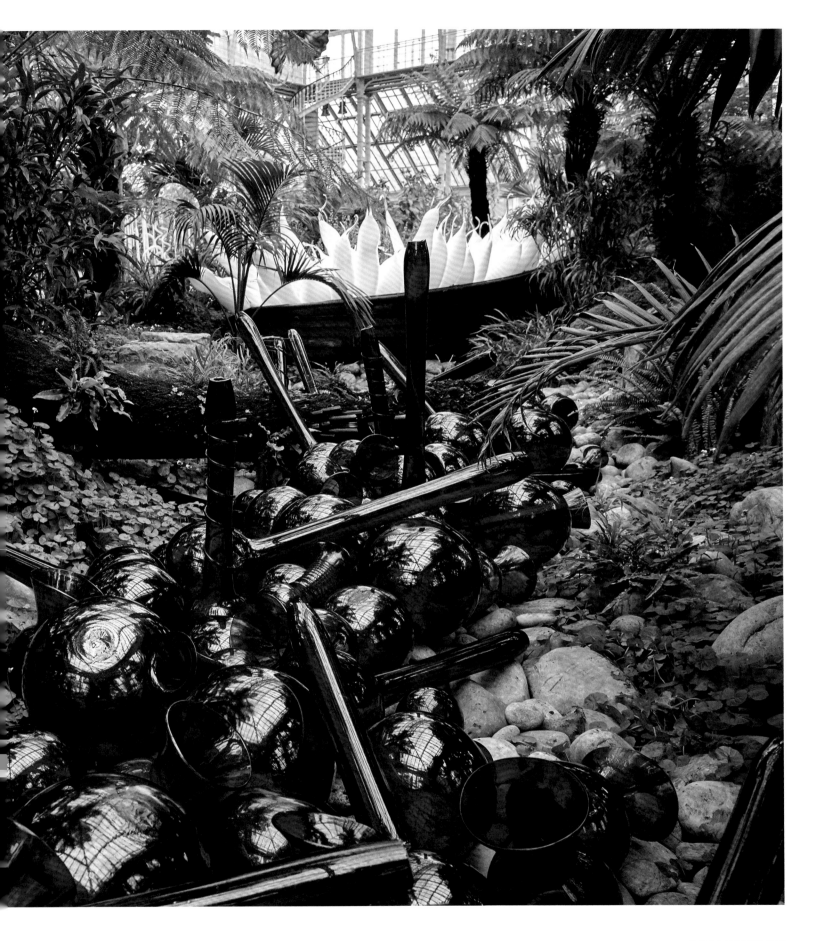

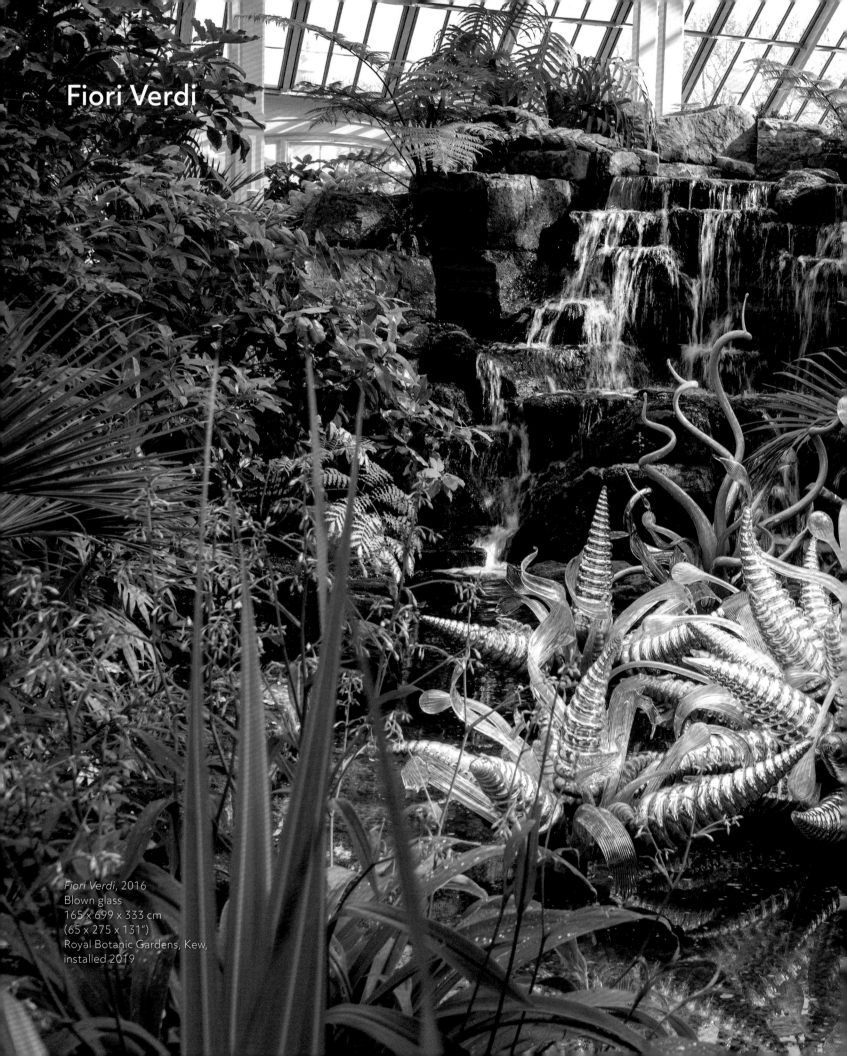

# Fiori Verdi

*Fiori Verdi*, 2016
Blown glass
165 x 699 x 333 cm
(65 x 275 x 131")
Royal Botanic Gardens, Kew,
installed 2019

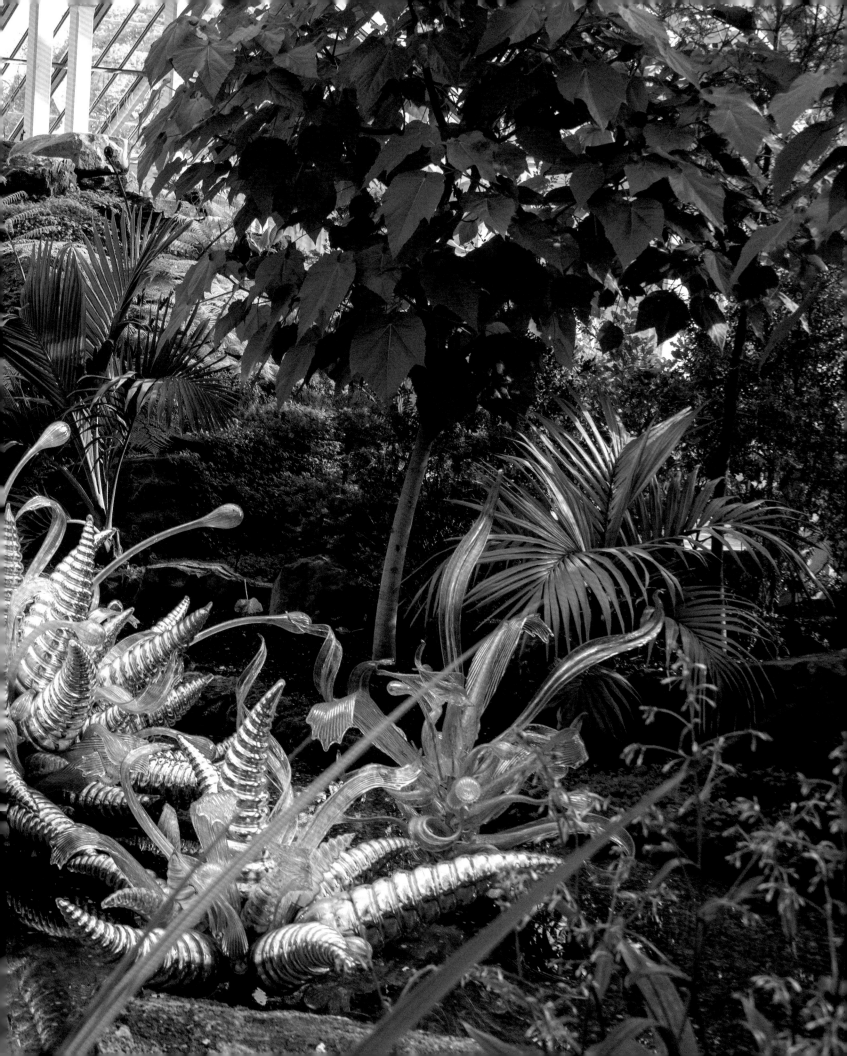

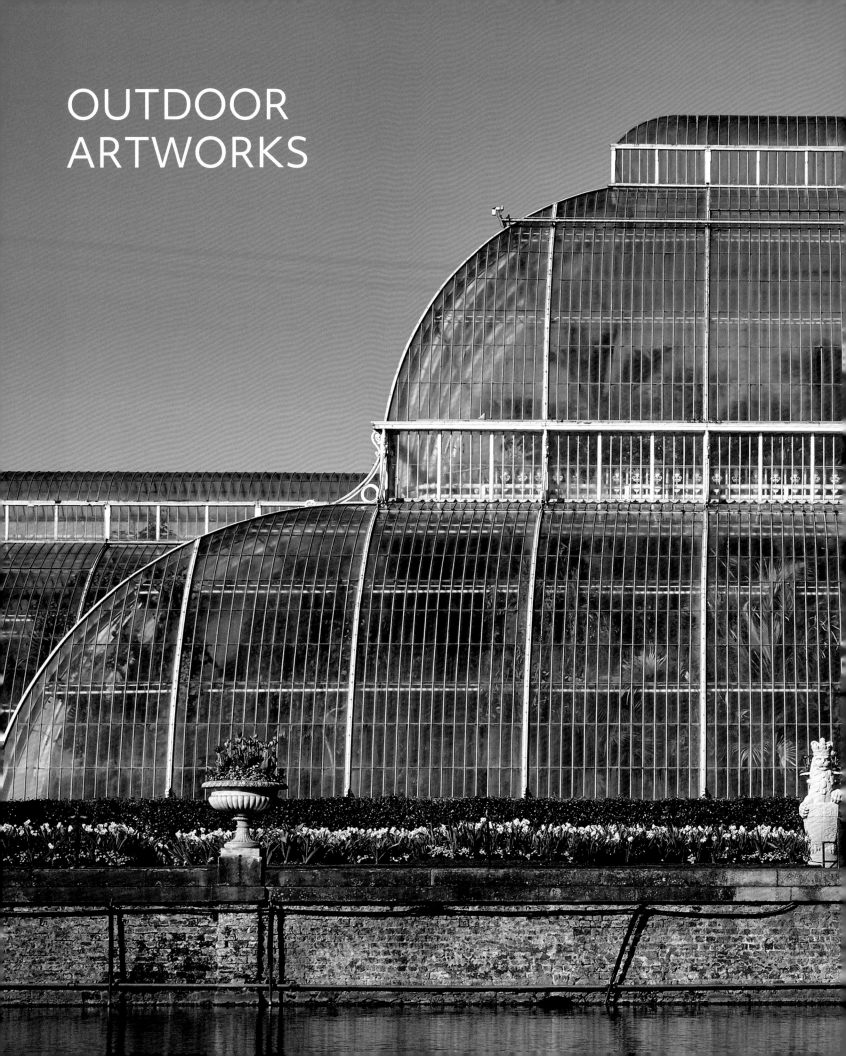

OUTDOOR
ARTWORKS

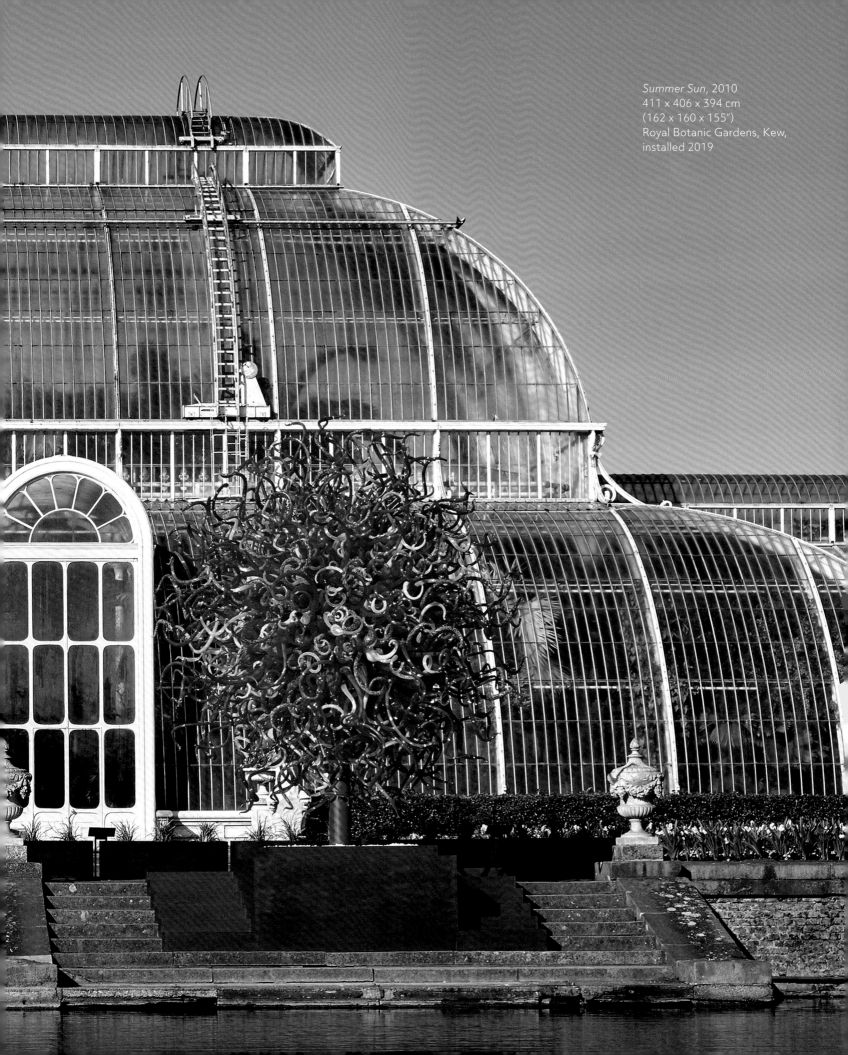

*Summer Sun*, 2010
411 x 406 x 394 cm
(162 x 160 x 155")
Royal Botanic Gardens, Kew,
installed 2019

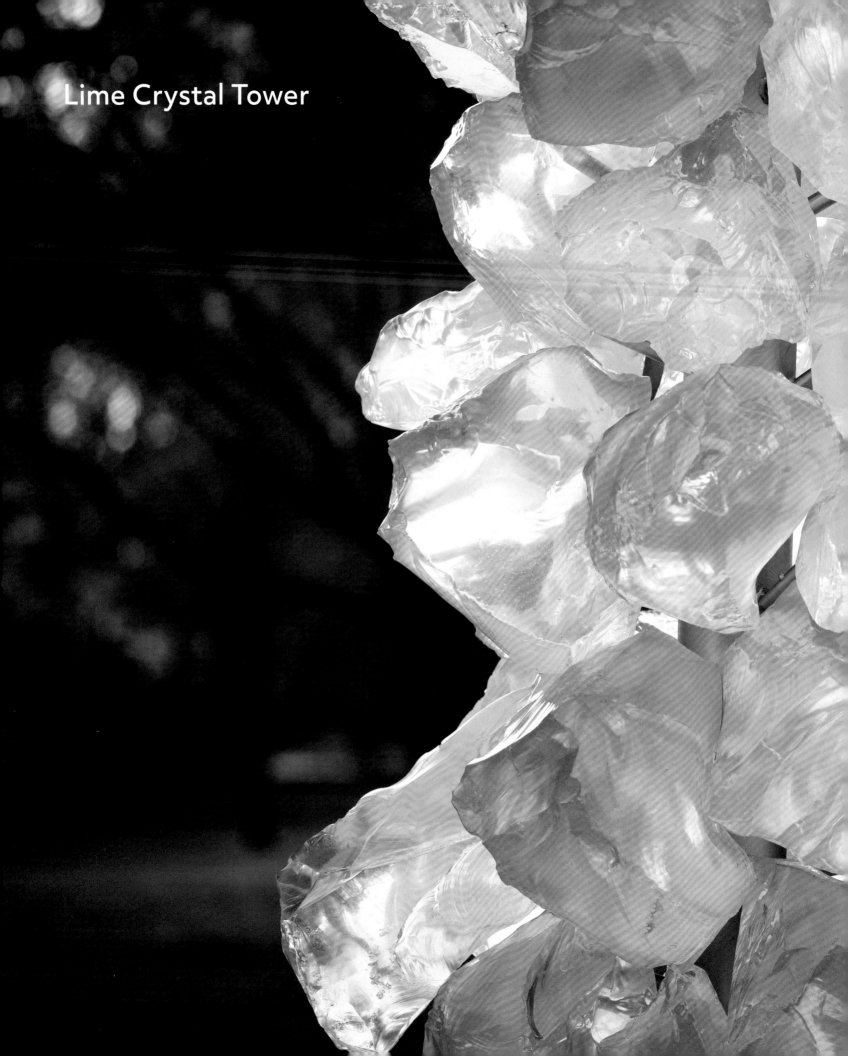

Lime Crystal Tower

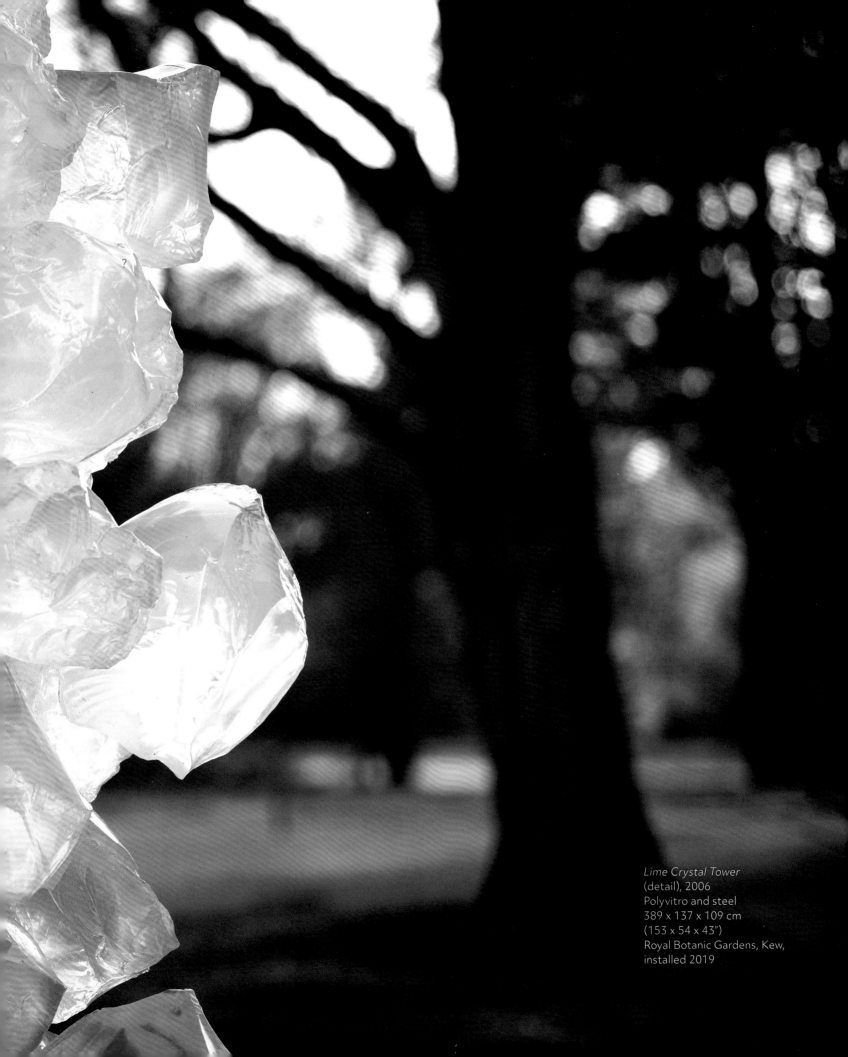

*Lime Crystal Tower*
(detail), 2006
Polyvitro and steel
389 x 137 x 109 cm
(153 x 54 x 43")
Royal Botanic Gardens, Kew,
installed 2019

*Lime Crystal Tower*, 2006
Polyvitro and steel
389 x 137 x 109 cm
(153 x 54 x 43")
Royal Botanic Gardens,
Kew, installed 2019

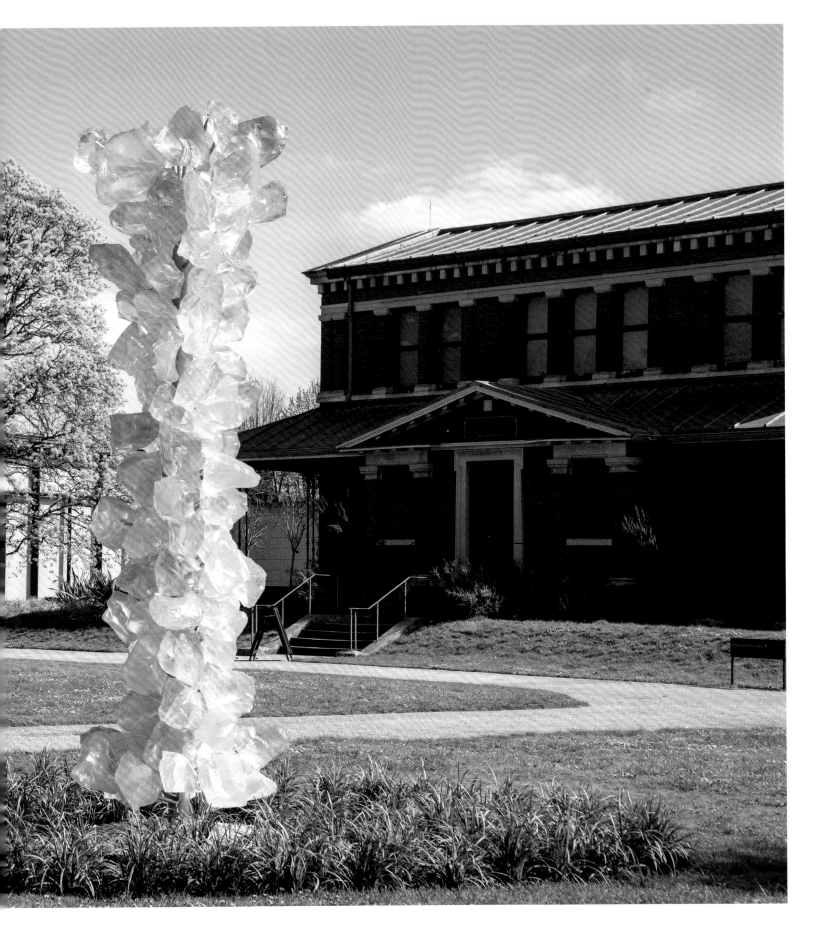

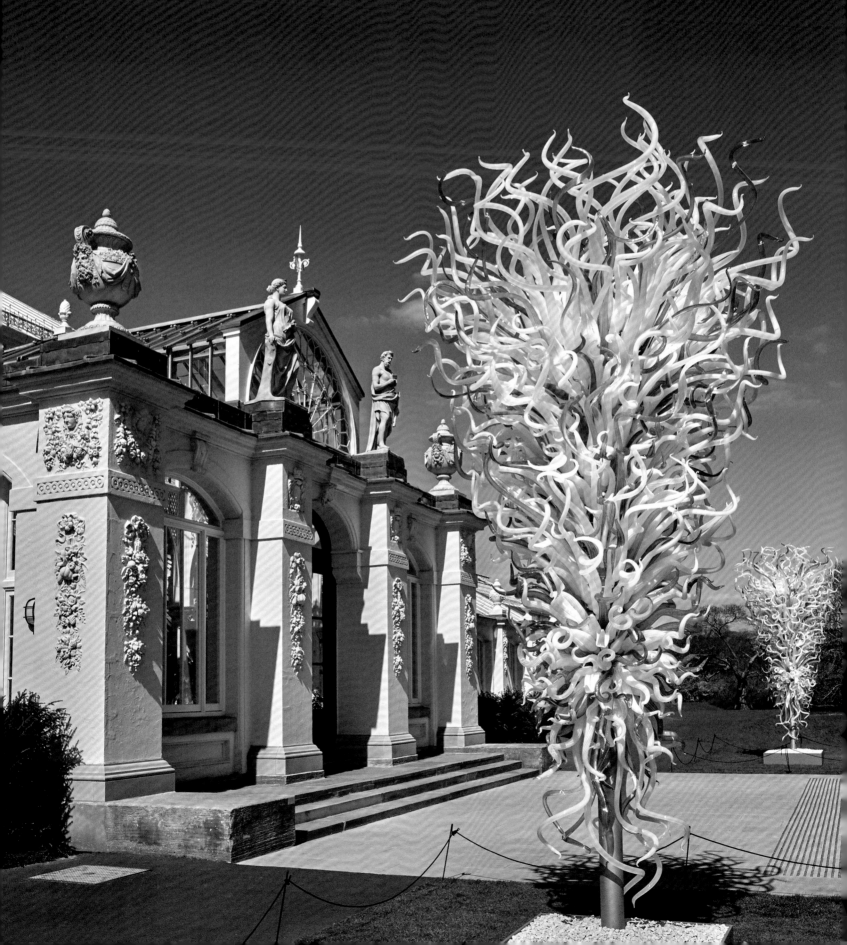

Opal and Amber Towers

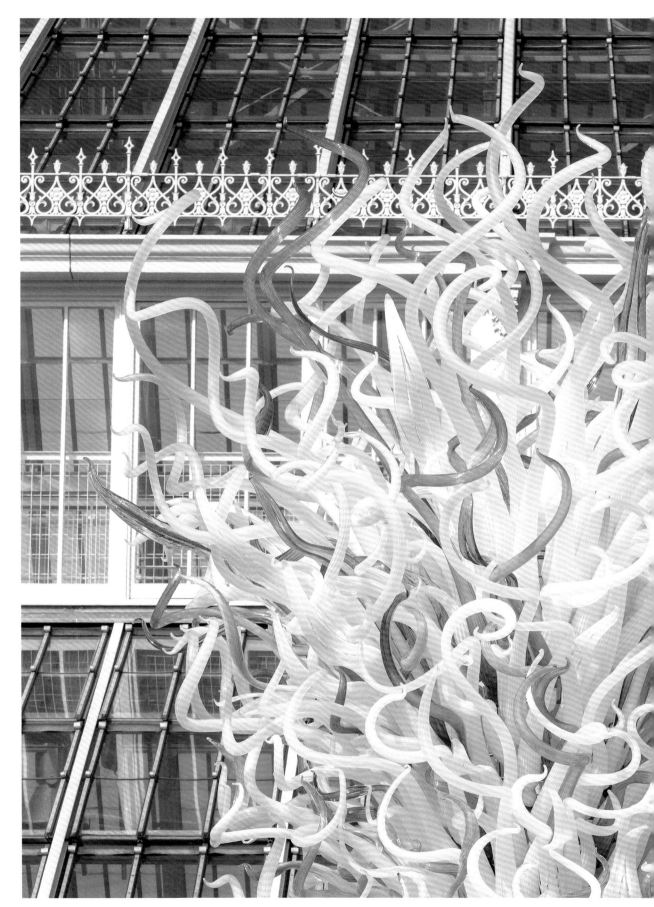

*Opal and Amber Towers,*
2018
Blown glass and steel
Royal Botanic Gardens, Kew,
installed 2019

# Niijima Floats

*'I named* Floats *after the Japanese fishing floats that washed up on the shores of the Pacific. They were used to hold fishing nets afloat and would sometimes break away and drift ashore'.*

**Dale Chihuly**

*Niijima Floats*, 2019
Blown glass
Royal Botanic Gardens, Kew
installed 2019

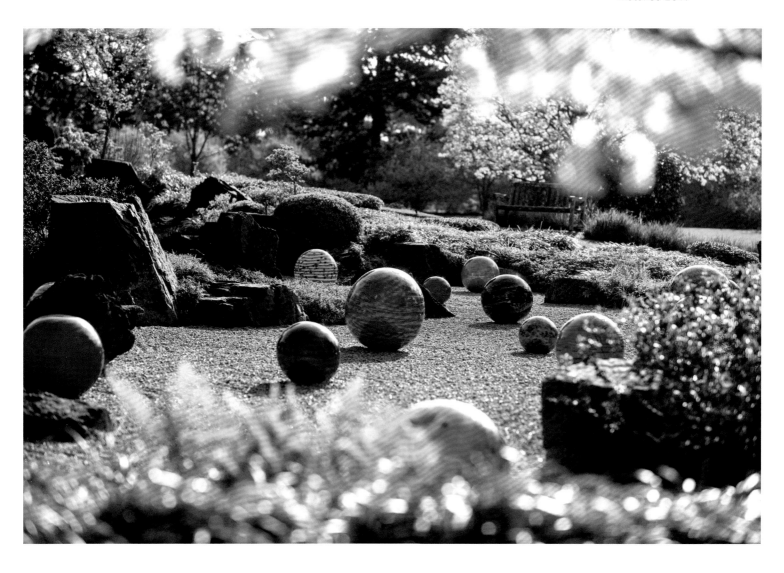

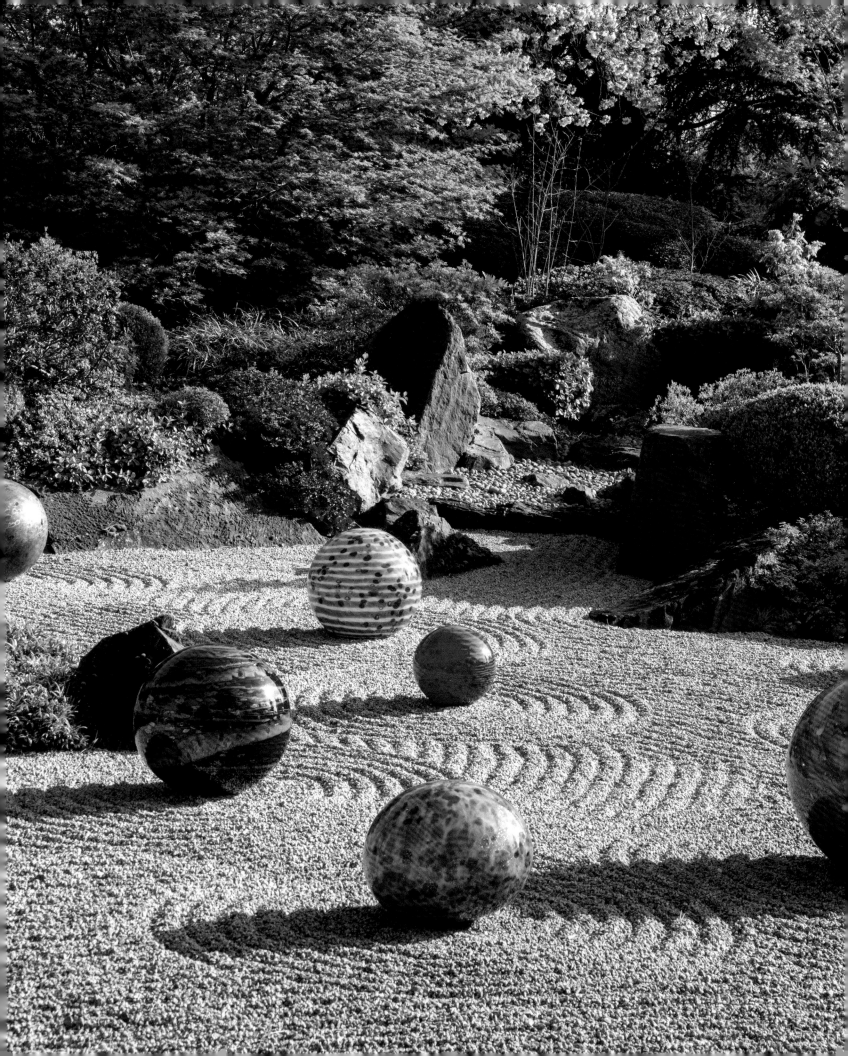

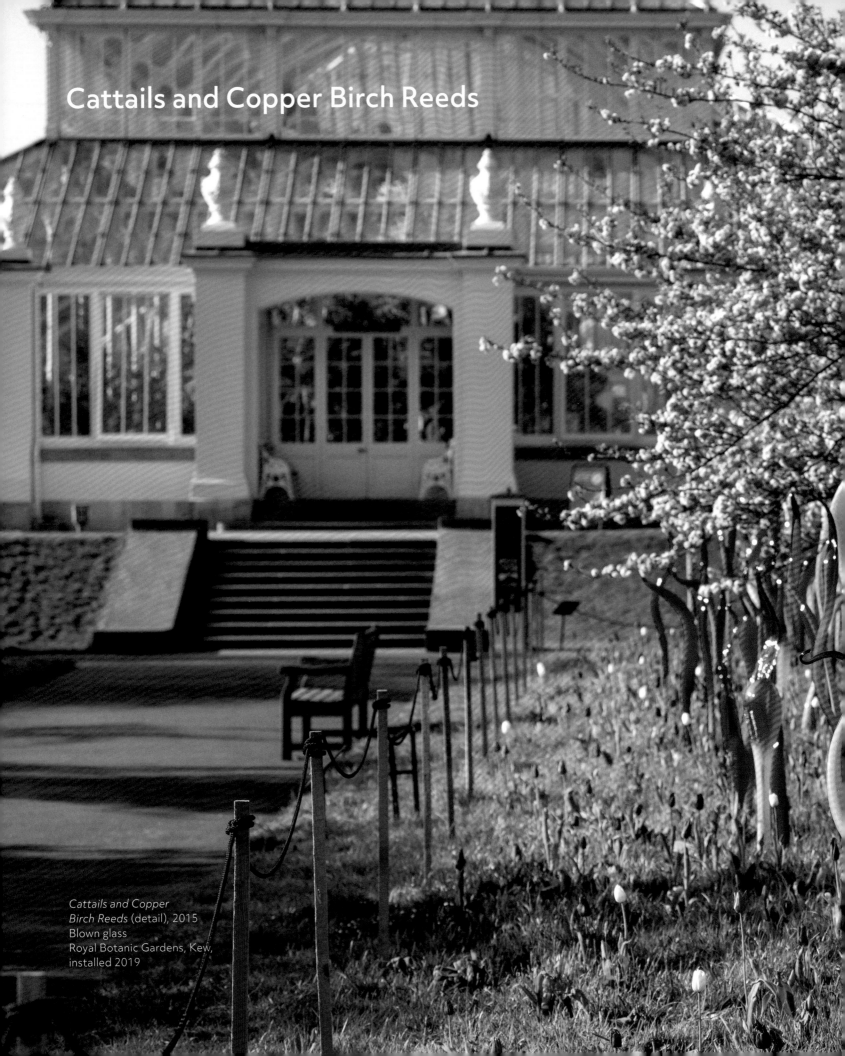

# Cattails and Copper Birch Reeds

*Cattails and Copper
Birch Reeds* (detail), 2015
Blown glass
Royal Botanic Gardens, Kew,
installed 2019

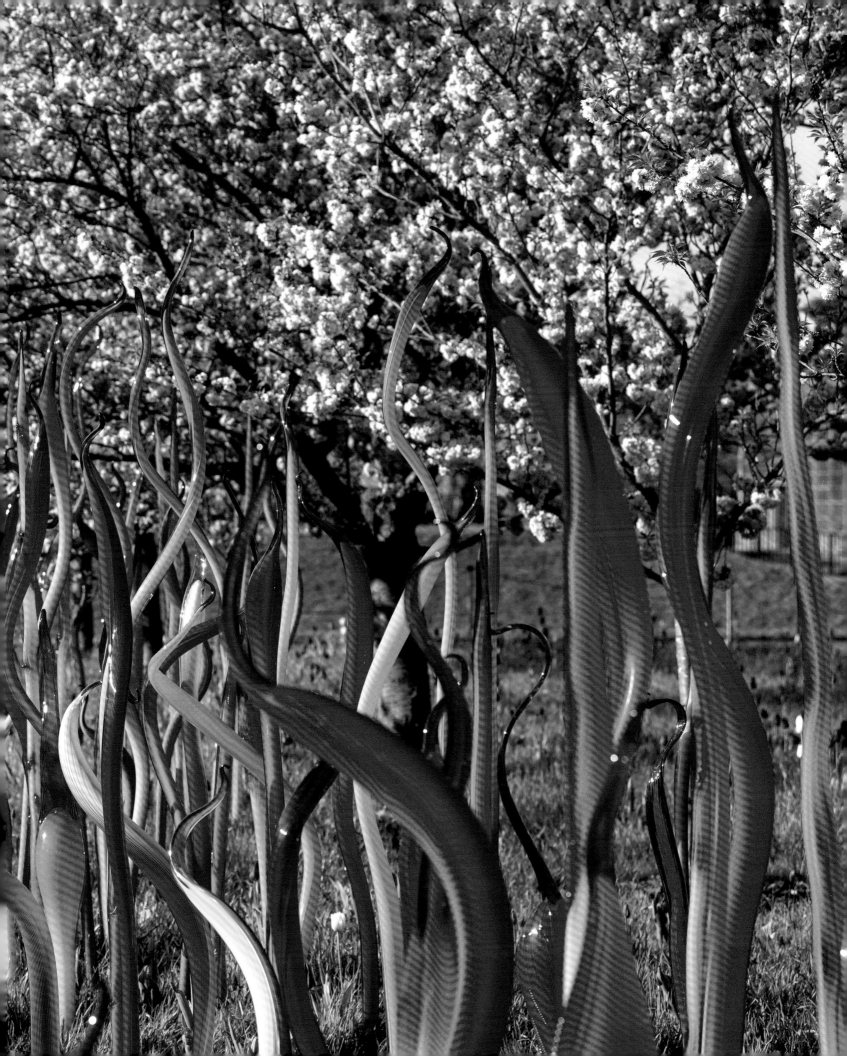

# Neodymium Reeds and Turquoise Marlins

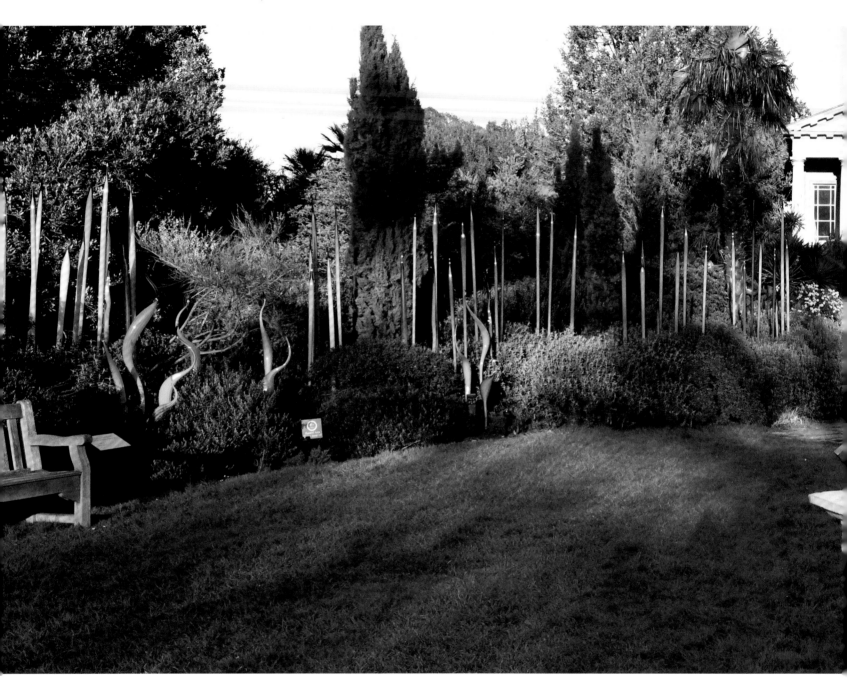

*Neodymium Reeds and
Turquoise Marlins*
Blown glass
305 x 1920 x 1433 cm
(120 x 756 x 564")
Royal Botanic Gardens, Kew,
installed 2019

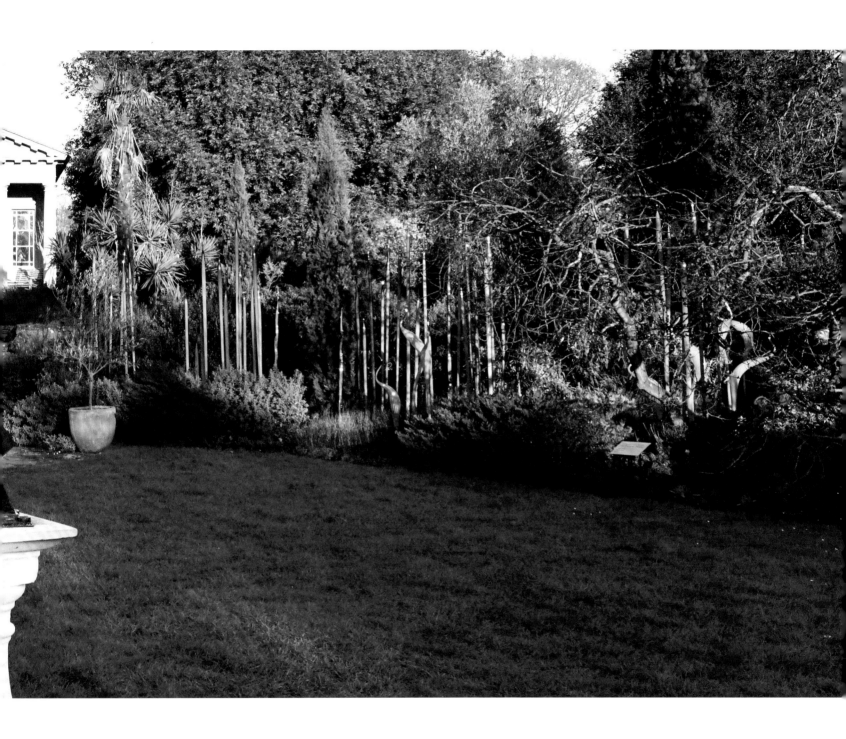

# Scarlet and Yellow Icicle Tower

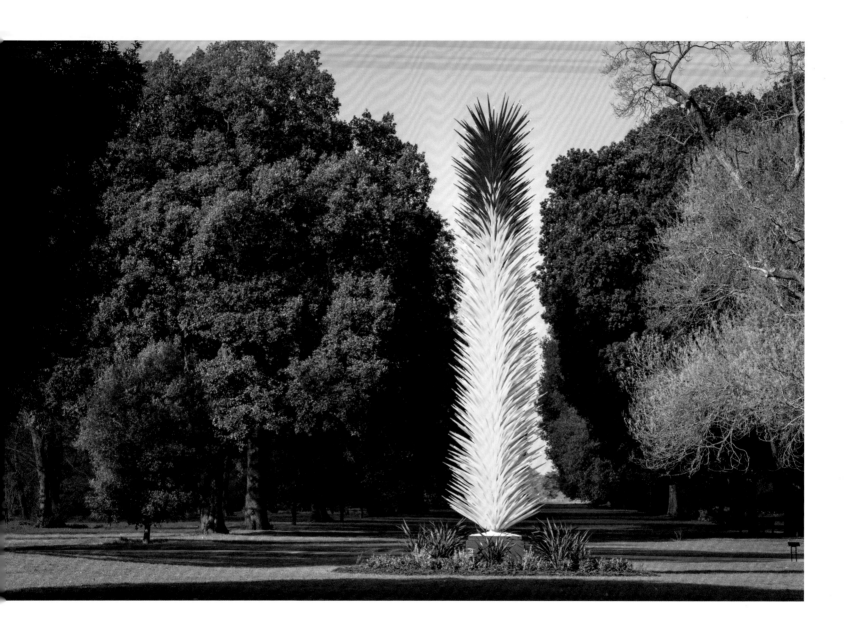

*Scarlet and Yellow Icicle Tower,*
2013
Blown glass and steel
925 x 229 x 224 cm
(364 x 90 x 88")
Royal Botanic Gardens, Kew,
installed 2019

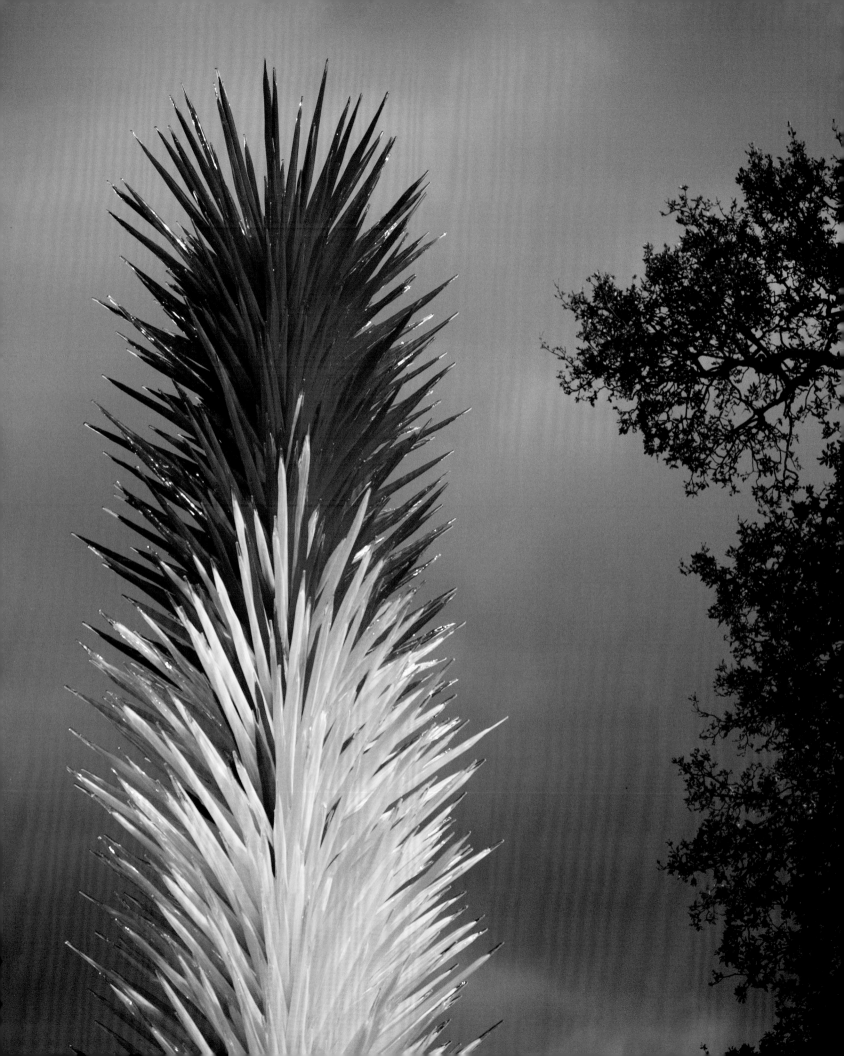

# Red Reeds

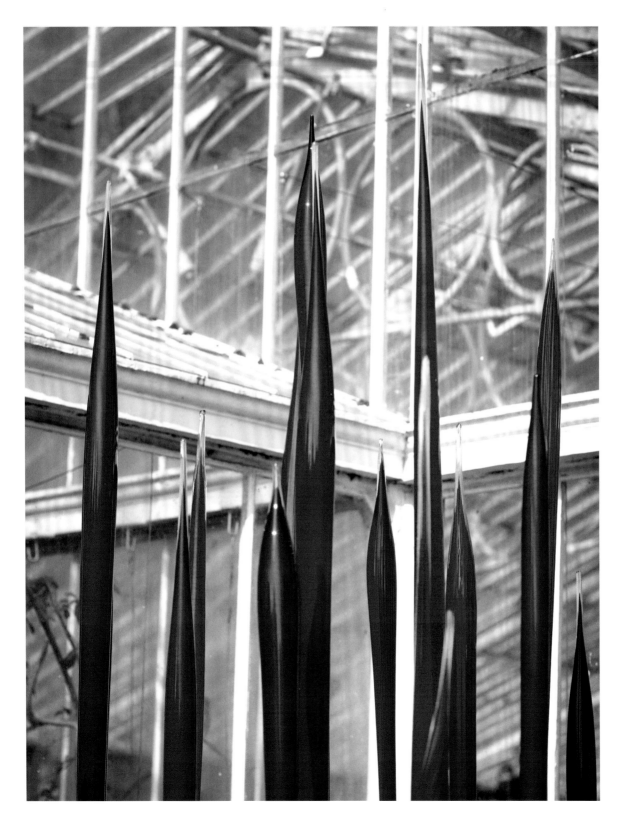

*Red Reeds*, 2016
Blown glass
Royal Botanic Gardens, Kew,
installed 2019

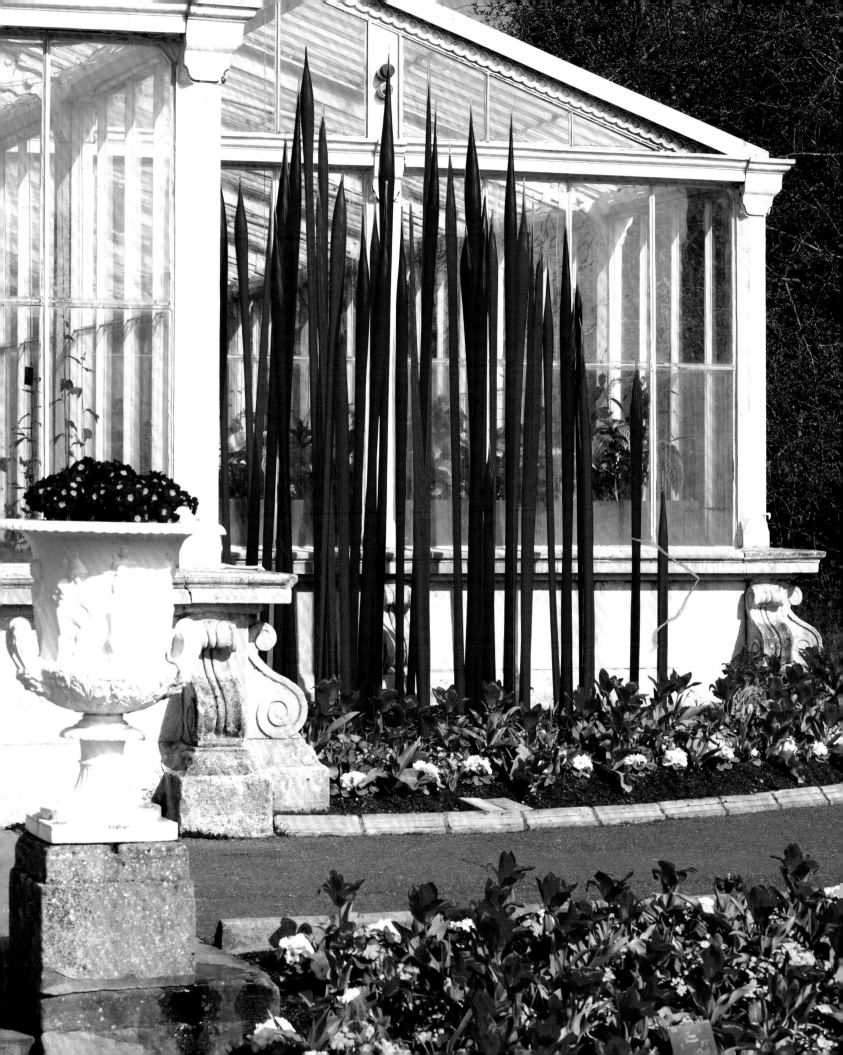

# Ethereal White
# Persian Pond

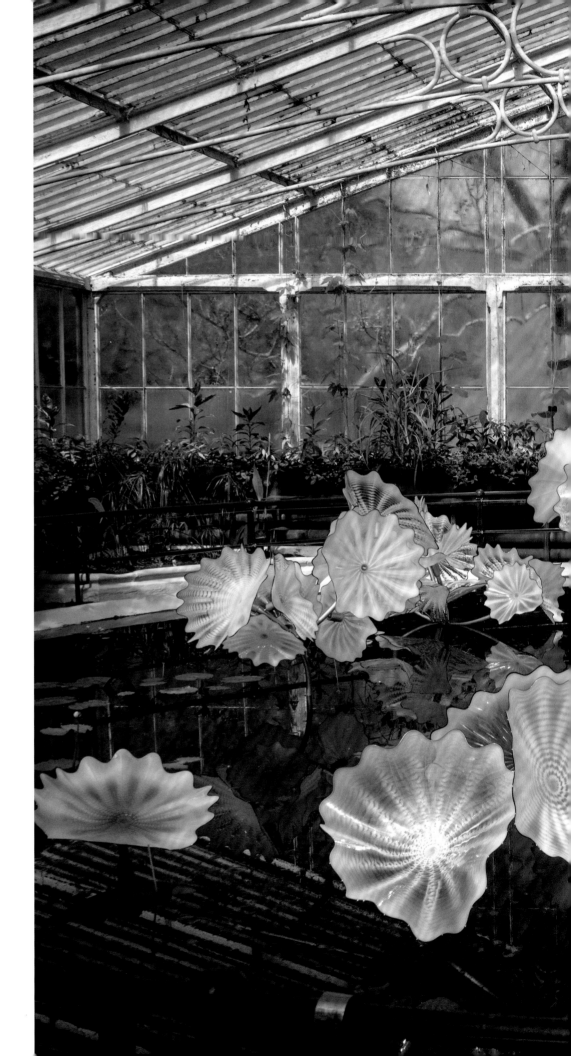

*Ethereal White Persian Pond*,
2018
Blown glass and steel
234 x 798 x 599 cm
(92 x 314 x 236")
Royal Botanic Gardens, Kew,
installed 2019

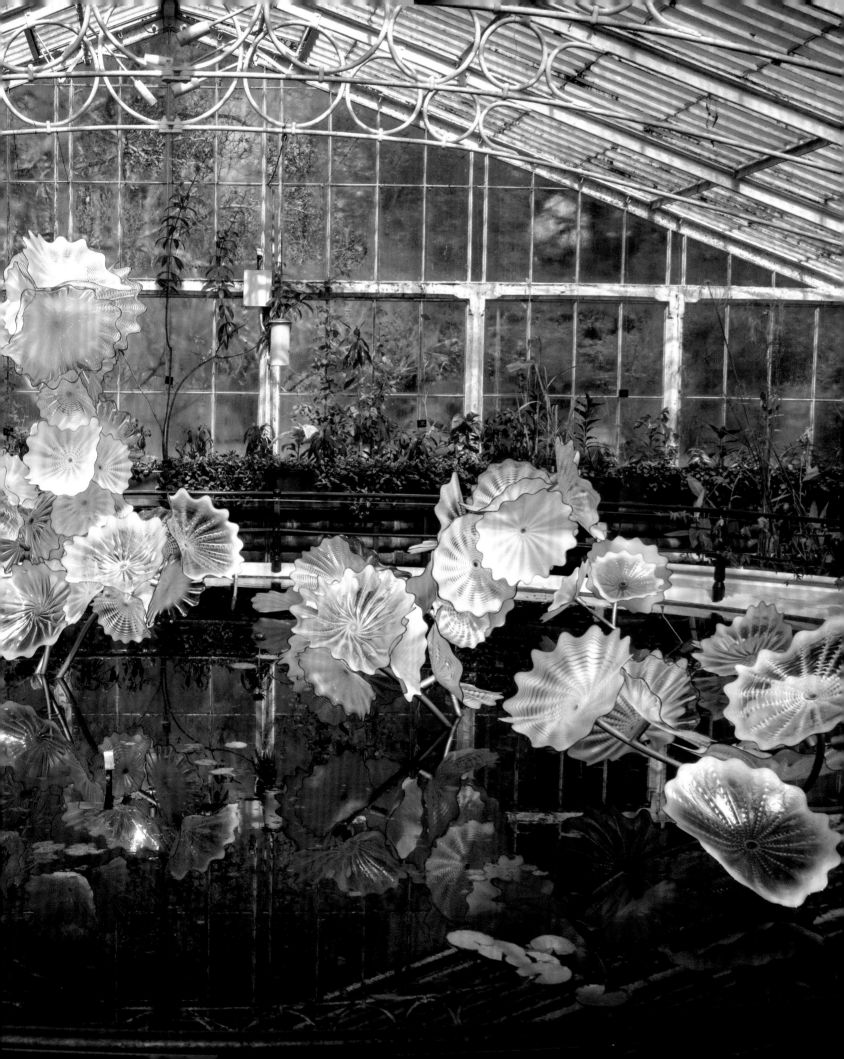

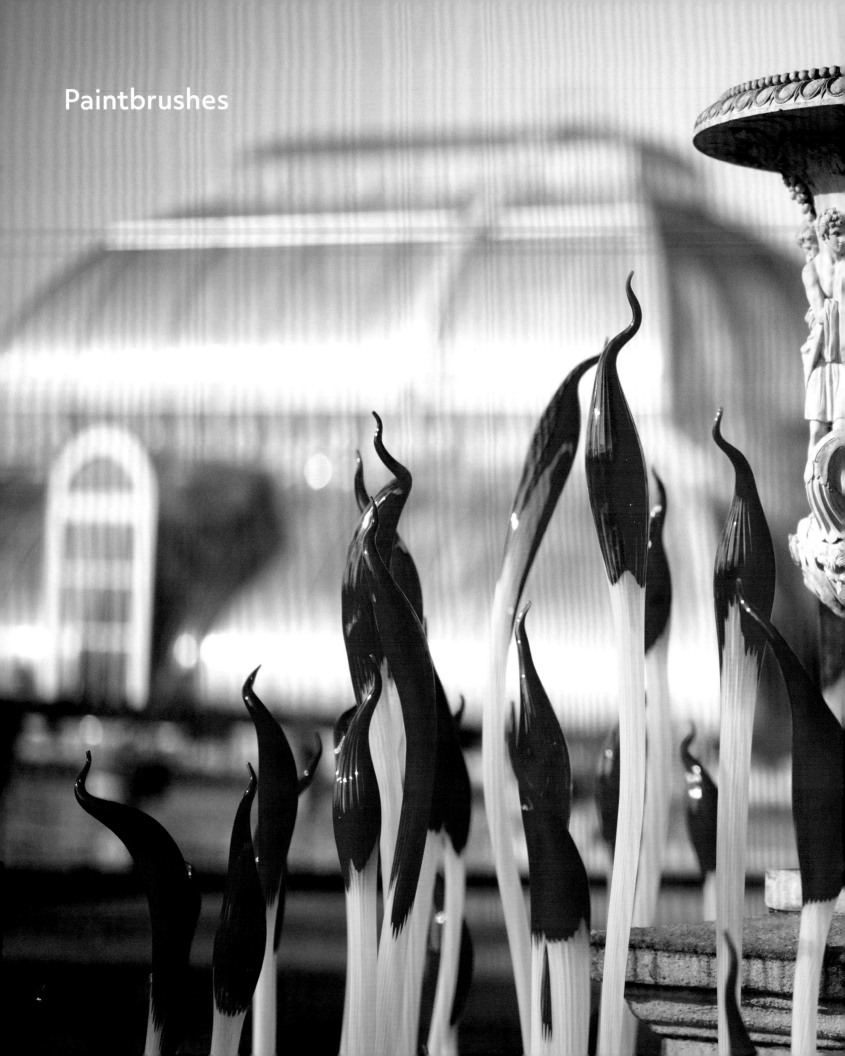

Paintbrushes

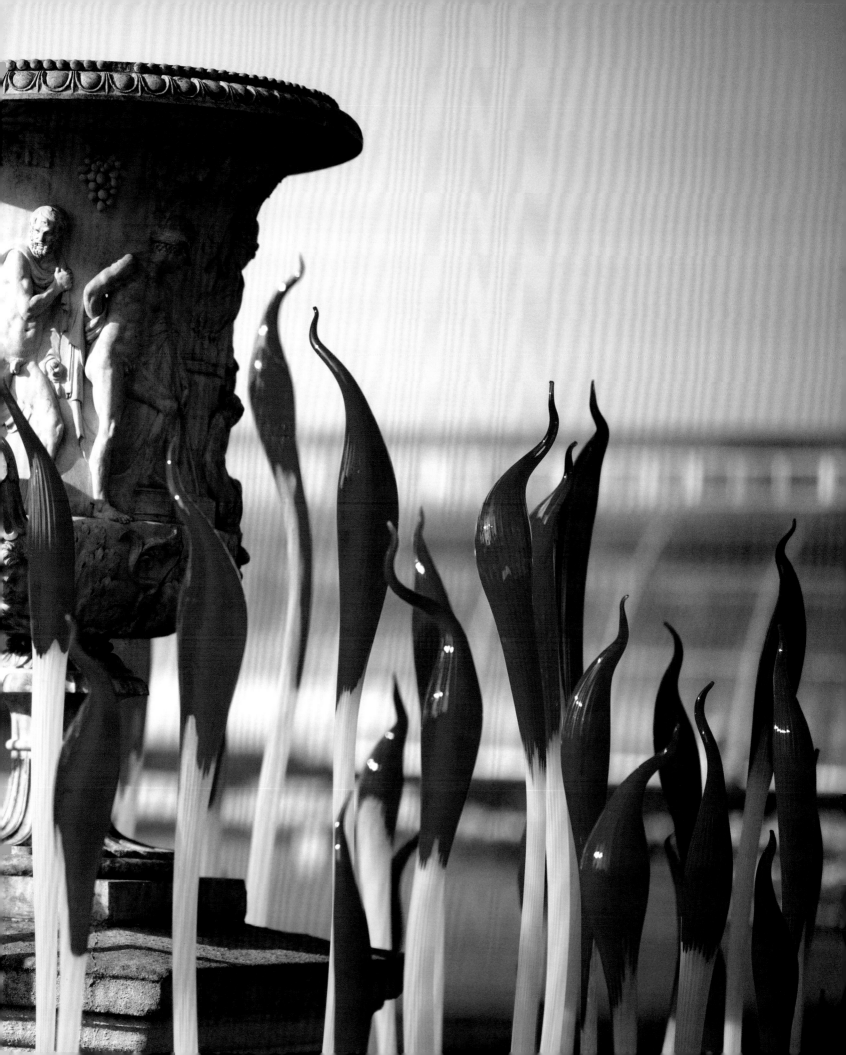

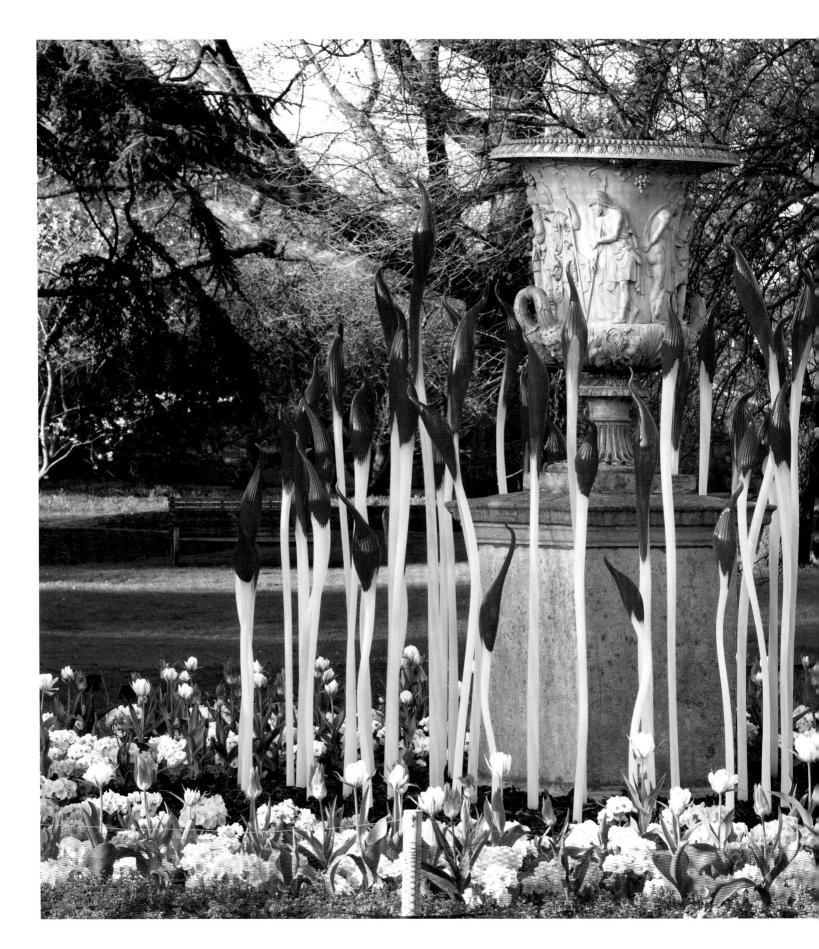

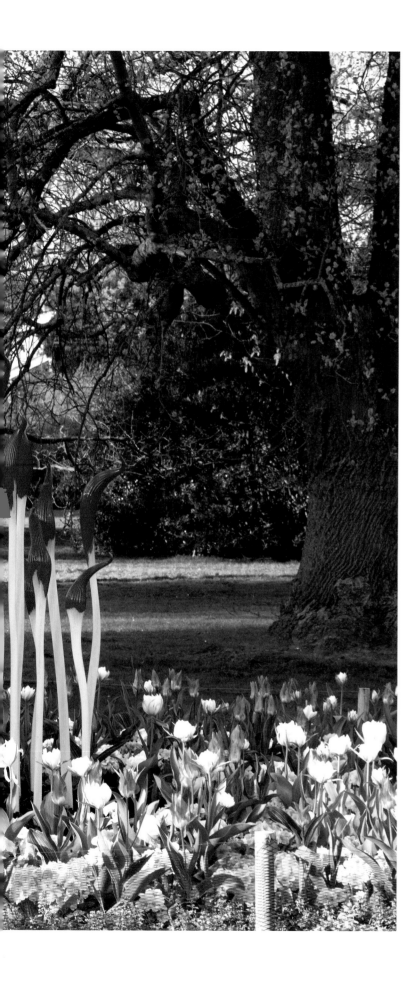

Previous page:
*Paintbrushes* (detail), 2016
Blown glass
221 x 300 x 287 cm
(87 x 118 x 113")
Royal Botanic Gardens, Kew,
installed 2019

*Paintbrushes*, 2016
Blown glass
221 x 300 x 287 cm
(87 x 118 x 113")
Royal Botanic Gardens, Kew,
installed 2019

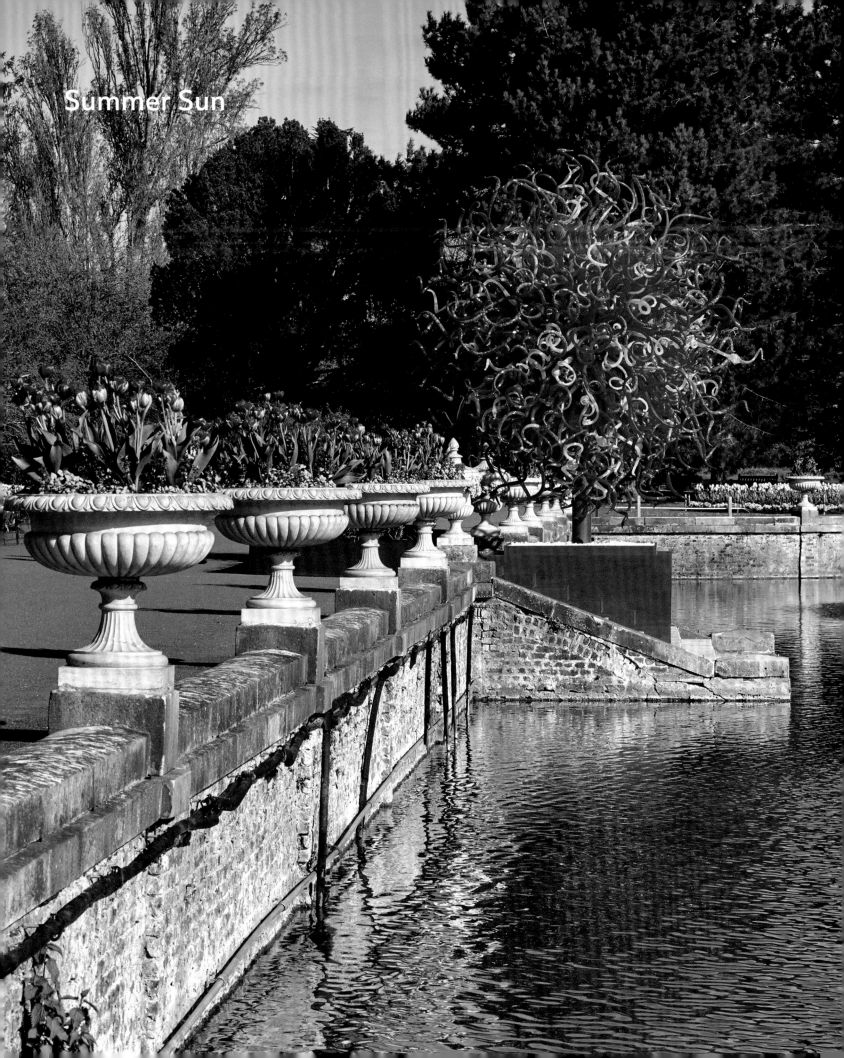

Summer Sun

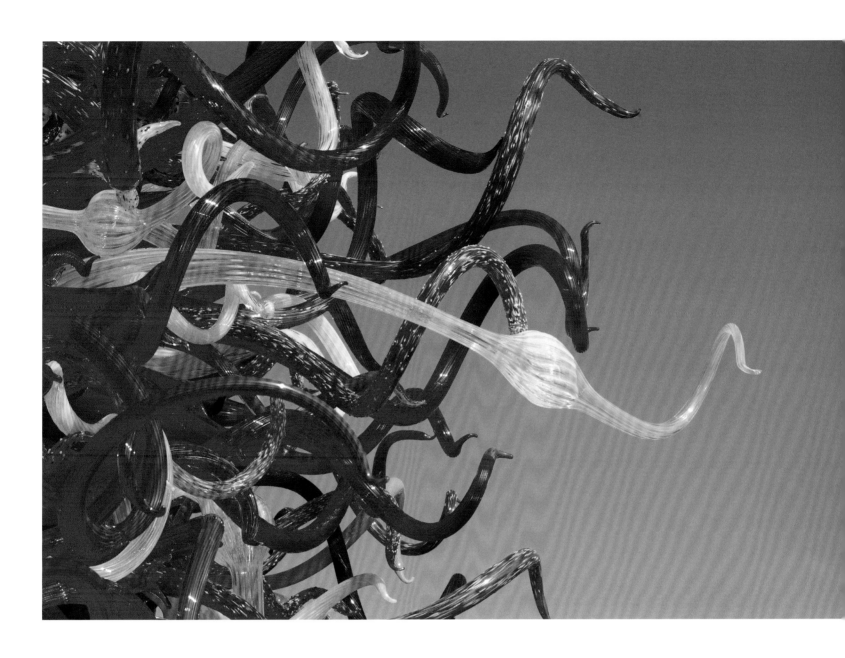

*Summer Sun*, 2010
Blown glass and steel
411 x 406 x 394 cm
(162 x 160 x 155")
Royal Botanic Gardens, Kew,
installed 2019

# DALE CHIHULY'S
# LIFE AND WORK

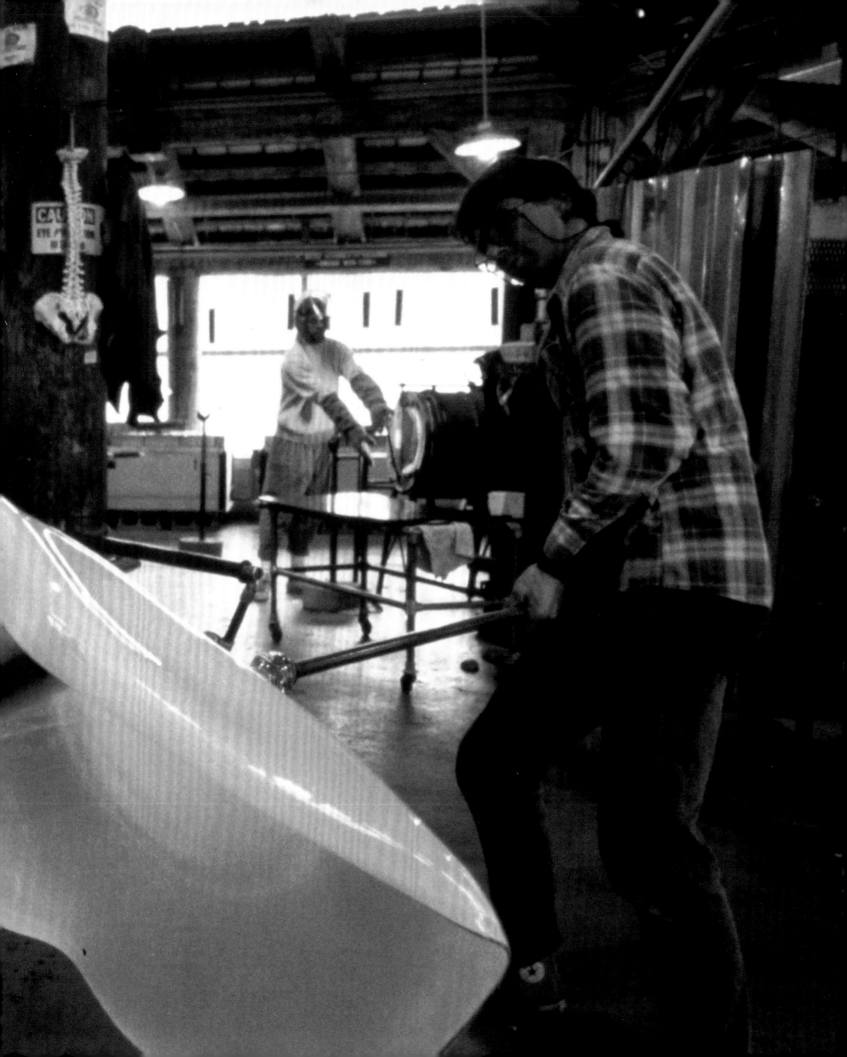

# DALE CHIHULY'S LIFE AND WORK

**1941**    Born September 20 in Tacoma, Washington, to George Chihuly and Viola Magnuson Chihuly.

**1957**    Older brother and only sibling, George, dies in a navy flight-training accident in Pensacola, Florida.

**1958**    His father suffers a fatal heart attack at age 51, and his mother has to go to work.

**1959**    Graduates from high school in Tacoma. Enrolls at College of Puget Sound (now University of Puget Sound) in his hometown.

**1960**    Transfers to University of Washington in Seattle, where he studies interior design and architecture.

**1961**    Joins Delta Kappa Epsilon fraternity and becomes rush chairman. Learns to melt and fuse glass.

**1962**    Interrupts his studies and travels to Florence to focus on art. Frustrated by his inability to speak Italian, he moves on to the Middle East.

**1963**    Works on a kibbutz in Negev desert, Israel. Reinspired, returns to University of Washington and studies interior design under Hope Foote and Warren Hill. In a weaving class with Doris Brockway, incorporates glass shards into woven tapestries.

**1964**    Returns to Europe, visiting Leningrad and making the first of many trips to Ireland.

**1965**    Receives BA in interior design from University of Washington. In his basement studio, blows his first glass bubble by melting stained glass and using a metal pipe.

Previous page:
Chihuly, Paul DeSomma,
and Richard Royal
Pilchuck Glass School,
Stanwood, Washington,
c. 1986

**1966**    Earns money for graduate school as a commercial fisherman in Alaska. Enters University of Wisconsin at Madison on a full scholarship, to study glassblowing in the first glass programme in the United States, taught by Harvey Littleton.

**1967**    After receiving MS in sculpture from University of Wisconsin, enrolls at Rhode Island School of Design (RISD) in Providence, where he begins exploration of environmental works using neon, argon, and blown glass. Awarded a Louis Comfort Tiffany Foundation Grant for work in glass. Artist Italo Scanga lectures at RISD, and the two start a lifelong friendship.

**1968**    Receives MFA from RISD. Spends the first of four consecutive summers teaching at Haystack Mountain School of Crafts in Deer Isle, Maine. A Fulbright Fellowship awarded earlier in the year enables him to work and study in Europe. Becomes the first American glassblower to work in the prestigious Venini factory, on the island of Murano.

**1969**    Makes pilgrimages to meet glass masters Erwin Eisch in Germany and Stanislav Libenský and his wife, Jaroslava Brychtová, in Czechoslovakia. Establishes the glass programme at RISD, where he teaches for the next eleven years.

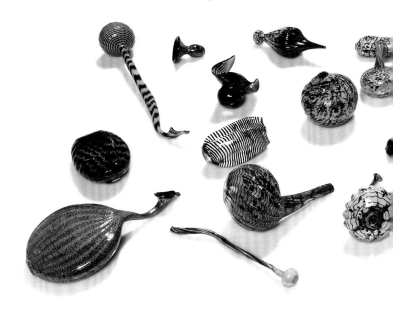

**1970** Meets James Carpenter, a student in RISD Architecture Department, and they begin a five-year collaboration.

**1971** On the site of a tree farm north of Seattle owned by art patrons Anne Gould Hauberg and John Hauberg, the Pilchuck Glass School experiment is started. *Pilchuck Pond*, Chihuly's first environmental installation at the school, is created that summer. In the fall, at RISD, he makes *20,000 Pounds of Ice and Neon*, *Glass Forest #1*, and *Glass Forest #2* with James Carpenter, installations that prefigure later environmental works by Chihuly.

**1972** Collaborates with James Carpenter on more large-scale architectural projects. They create *Rondel Door* and *Cast Glass Door* at Pilchuck. In Providence, they have a conceptual breakthrough with *Dry Ice, Bent Glass and Neon*.

**1974** Works with James Carpenter and a group of students at Pilchuck to develop a technique for picking up glass thread drawings and incorporating them into larger glass pieces.

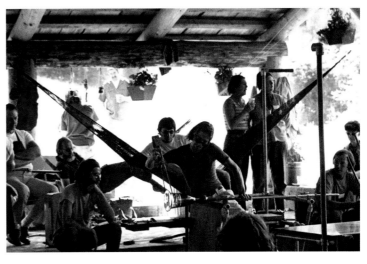

James Carpenter
Pilchuck Glass School,
Stanwood, Washington,
c. 1974

**1975** At RISD, begins *Navajo Blanket Cylinder* series. Kate Elliott and, later, Flora C. Mace fabricate the complex thread drawings for his artwork. He receives the first of two National Endowment for the Arts Visual Artists' Fellowships. Becomes artist-in-residence with Seaver Leslie at Artpark, an annual arts programme on the Niagara Gorge in New York State. Begins *Irish Cylinders* and *Ulysses Cylinders* with Leslie and Mace.

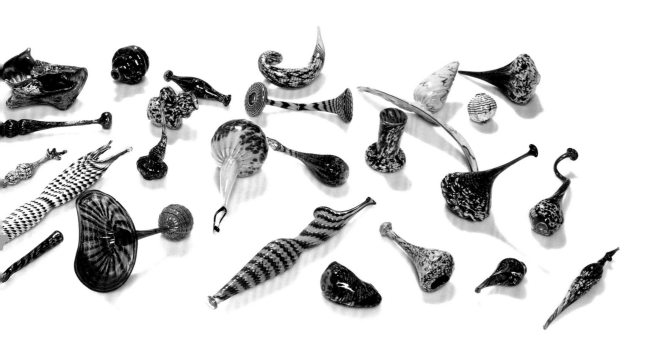

*Early Persians*, c. 1980s
Blown glass

*Blanket Cylinder* in process
The Boathouse hotshop,
Seattle, 1995

**1976** An automobile accident in England leaves him, after weeks in hospital and 256 stitches in his face, without sight in his left eye and with permanent damage to his right ankle and foot. After recuperating, he returns to Providence to serve as head of the Department of Sculpture and the Program in Glass at RISD. Henry Geldzahler, curator of contemporary art at the Metropolitan Museum of Art in New York, acquires three *Navajo Blanket Cylinders* for the museum's collection – a turning point in Chihuly's career and the start of the artist's friendship with both the curator and the museum director then, Thomas Hoving.

**1977** His *Basket* series – inspired by Northwest Native American baskets he sees at Washington State History Museum in Tacoma – is first made at Pilchuck with Benjamin Moore as gaffer and exhibited at Seattle Art Museum. Continues teaching at both RISD and Pilchuck.

**1978** Meets William Morris at Pilchuck, and the two begin a close, eight-year working relationship. Another career milestone is a solo exhibition at the Renwick Gallery, a branch of the Smithsonian American Art Museum, Washington, D.C.

**1979** Dislocates his shoulder in a bodysurfing accident and relinquishes the gaffer position for good. William Morris becomes his chief gaffer for several years. Chihuly begins to make drawings as a way to communicate his designs.

**1980** Resigns his teaching position at RISD but returns periodically in the 1980s as artist-in-residence. Begins *Seaform* series. Creates his first architectural commission: windows for Shaare Emeth Synagogue in St. Louis.

**1981** Begins *Macchia* series.

**1982** First catalogue is published: *Chihuly Glass*, designed by RISD colleague and friend Malcolm Grear.

**1983** Returns to Pacific Northwest after 16 years on the East Coast.

**1984** Begins work on *Soft Cylinder* series, with Flora C. Mace and Joey Kirkpatrick executing the glass drawings. Honoured as RISD President's Fellow at the Whitney Museum in New York.

**1985** Purchases the Buffalo Shoe Company Building just east of Lake Union in Seattle and begins restoring it for use as his studio.

**1986** Begins *Persian* series with Martin Blank as gaffer, assisted by Robbie Miller. Establishes his first hotshop in Van de Kamp Building near Lake Union in Seattle. *Dale Chihuly Objets de Verre* opens at Musée des Arts Décoratifs, Palais du Louvre, in Paris.

**1987** Donates permanent collection to Tacoma Art Museum in memory of his brother and father (adding works to the collection years later in memory of his mother). Marries playwright Sylvia Peto.

**1988** Inspired by Italian Art Deco glass, begins *Venetian* series with Italian glass master Lino Tagliapietra, working from Chihuly's drawings; Benjamin Moore also plays a very important role, including translator.

**1989** With Lino Tagliapietra and fellow glass master Pino Signoretto, as well as a team of glassblowers, begins *Putti* series at Pilchuck. With Tagliapietra, Chihuly creates *Ikebana* series, inspired by travels to Japan and exposure to ikebana masters.

**1990**　Purchases Pocock Building located on Lake Union, realizing his dream of being on the water in Seattle. Renovated and renamed the Boathouse, it serves as studio and hotshop. Returns to Japan.

**1991**　Begins *Niijima Float* series with Richard Royal as gaffer, creating some of the largest pieces of glass ever blown by hand. Chihuly and Sylvia Peto divorce.

**1992**　Begins *Chandelier* series with a hanging sculpture at Seattle Art Museum. Designs sets for Seattle Opera's 1993 production of Debussy's *Pelléas et Mélisande*.

**1993**　With Lino Tagliapietra, begins *Piccolo Venetian* series. Creates *100,000 Pounds of Ice and Neon*, a temporary installation in Tacoma Dome.

**1994**　Creates five installations for Tacoma's Union Station Federal Courthouse. Supports Hilltop Artists, a glassblowing programme in Tacoma for at-risk youths, created by friend Kathy Kaperick. Within two years, the programme partners with Tacoma Public School District.

**1995**　An international project, *Chihuly Over Venice*, begins with a glassblowing session in Nuutajärvi, Finland, and subsequent blow at Waterford Crystal factory, Ireland.

**1996**　After a blow in Monterrey, Mexico, *Chihuly Over Venice* culminates with the installation of fourteen *Chandeliers* around Venice and a glassblowing session with Pino Signoretto and Lino Tagliapietra on Murano. Creates his first permanent outdoor installation, *Icicle Creek Chandelier*, for Sleeping Lady resort in Leavenworth, Washington.

**1997**　Expands series of experimental plastics he calls Polyvitro. Travels to Japan to blow glass at Niijima Glass Art Center and creates several temporary outdoor Float installations. Travels with his team to a glass factory in Vianne, France, and they work with local glassblowers to create new works, some using industrial molds.

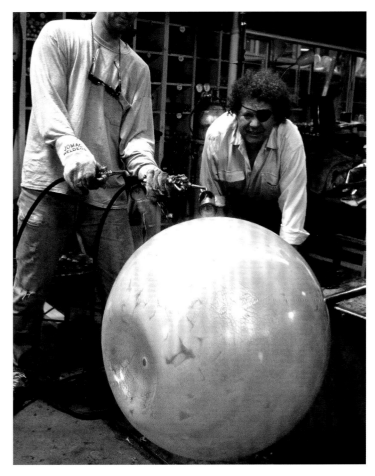

Richard Royal and Chihuly
The Boathouse hotshop,
Seattle, 1991

**1998**　Participates in Sydney Arts Festival in Australia. A son, Jackson Viola Chihuly, is born February 12 to Dale Chihuly and Leslie Jackson. Creates architectural installations for Benaroya Hall, Seattle; Bellagio, Las Vegas; and Atlantis, Bahamas.

**1999**　Begins *Jerusalem Cylinder* series with gaffer James Mongrain. Chihuly starts an ambitious exhibition, *Chihuly in the Light of Jerusalem 2000*, at Tower of David Museum of the History of Jerusalem. Just outside the museum, builds a sixty-foot-long wall made of twenty-four massive blocks of ice shipped from Alaska.

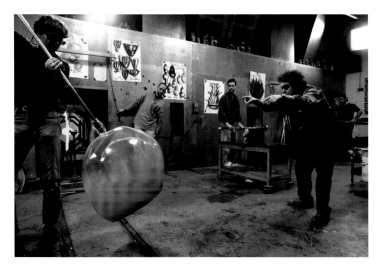

Richard Royal, Charles
Parriott, David Levy,
Chihuly, and Brian Brenno
The Boathouse hotshop,
Seattle, 1993

**2004** Orlando Museum of Art and Museum of Fine Arts,
St. Petersburg, Florida, collaborate and present
complementary exhibitions of his work. Installs
garden exhibition at Atlanta Botanical Garden.

**2005** Marries Leslie Jackson. Installs garden exhibition
at Royal Botanic Gardens, Kew, London.
Exhibits at Fairchild Tropical Botanic Garden,
Coral Gables, Florida.

**2006** Mother, Viola, dies at age 98 in Tacoma. Between
April and June, begins *Black* series; exhibits at
Missouri Botanical Garden, St. Louis; begins *Clear*
series; and exhibits at New York Botanical Garden.
*Chihuly in Tacoma* – a weeklong residency featuring
hotshop sessions at Museum of Glass – reunites
Chihuly and glassblowers from important periods
of his career.

**2000** Creates *La Tour de Lumière* sculpture as part of
*Contemporary American Sculpture* exhibition in
Monte Carlo. More than one million visitors enter
Tower of David Museum to see *Chihuly in the Light
of Jerusalem 2000*, breaking the world attendance
record for a temporary exhibition during 1999–2000.

**2001** *Chihuly at the V&A* opens at Victoria and Albert
Museum, London. Artist Italo Scanga dies after
more than three decades as friend and mentor.
*Chihuly in the Park: A Garden of Glass*, at Garfield
Park Conservatory, Chicago, begins *Garden Cycle*, a
series of exhibitions in conservatories and gardens.

**2002** Creates large-scale installations for Winter Olympic
Games in Salt Lake City. Chihuly Bridge of Glass
is dedicated in Tacoma; conceived by Chihuly and
designed in collaboration with Arthur Andersson
of Andersson-Wise Architects, it is a pedestrian
overpass featuring three permanent installations of
Chihuly's work.

**2003** Begins *Fiori* series with gaffer Joey DeCamp and
creates first *Mille Fiori*, for exhibition at Tacoma Art
Museum. A garden exhibition opens at Franklin Park
Conservatory, Columbus, Ohio.

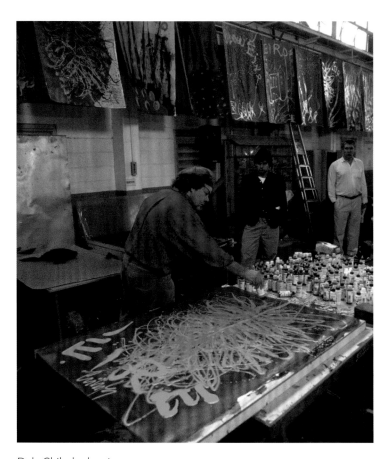

Dale Chihuly drawing
at the Waterford
Crystal glass factory
Waterford, Ireland, 1995

**2007**  Exhibits at Phipps Conservatory and Botanical Gardens, Pittsburgh. Creates stage set for Seattle Symphony's production of Béla Bartók's opera, *Bluebeard's Castle*; the set will be used for years in productions in several American cities as well as Tel Aviv, Israel.

**2008**  Presents exhibition at de Young Museum, San Francisco. Returns to his alma mater with an exhibition at RISD Museum of Art. Exhibits at Desert Botanical Garden in Phoenix.

**2009**  Begins *Silvered* series. Participates in 53rd Venice Biennale with *Mille Fiori Venezia* installation. Returns to Franklin Park Conservatory, Columbus, Ohio, with a garden exhibition. Creates commission with multiple installations at island resort of Sentosa, Singapore.

**2010**  Creates temporary installations outdoors at Kennedy Center for Performing Arts in Washington, D.C., and Salk Institute for Biological Studies in La Jolla, California. Presents exhibitions at Frederik Meijer Gardens & Sculpture Park in Grand Rapids, Michigan, and Cheekwood Botanical Garden and Museum of Art, Nashville. Begins *White* series.

**2011**  Holds exhibitions at Museum of Fine Arts, Boston, and Tacoma Art Museum.

**2012**  Exhibits at Dallas Arboretum and Botanical Garden. *Chihuly Garden and Glass* opens at Seattle Center; the long-term exhibition of the artist's work features gallery spaces, a sculpture garden, and a glasshouse designed by Chihuly. Exhibits at Virginia Museum of Fine Arts, Richmond.

**2013**  Montreal Museum of Fine Arts holds exhibition of Chihuly art. Begins *Rotolo* series with gaffer James Mongrain. With Seaver Leslie, revisits the *Irish Cylinders* from nearly forty years ago with new *Ulysses Cylinders* inspired by the James Joyce novel.

**2014**  At Clinton Presidential Library and Museum, Little Rock, Arkansas, displays temporary installations. Exhibition opens at Denver Botanic Gardens. Shows the new *Ulysses Cylinders* at Dublin Castle in Ireland.

**2015**  An exhibition of Chihuly's drawings opens at Museum of Glass, Tacoma. The Toyama Glass Art Museum, in Toyama, Japan, commissions permanent installations of his work.

**2016**  Returns to Atlanta Botanical Garden. Exhibits at Royal Ontario Museum, Toronto. His set for the opera *Bluebeard's Castle* appears in a production in Portland, Oregon.

**2017**  Creates a new body of work – *Glass on Glass* – by painting with vitreous-glass enamel on glass panels that are then kiln-fired. Returns to New York Botanical Garden. A permanent architectural space, *Chihuly Sanctuary*, opens at the Buffett Cancer Center, Omaha. Exhibits at Crystal Bridges Museum of American Art, Bentonville, Arkansas.

**2018**  Installs garden installation at Biltmore, Asheville, North Carolina. Exhibits his art with that of Stanislav Libenský and Jaroslava Brychtová at DOX Centre for Contemporary Art, Prague, celebrating their longtime friendship. Groninger Museum in Groningen, the Netherlands, opens Chihuly exhibition.

**2019**  Returns to the Royal Botanic Gardens, Kew with *Chihuly: Reflections on nature*.

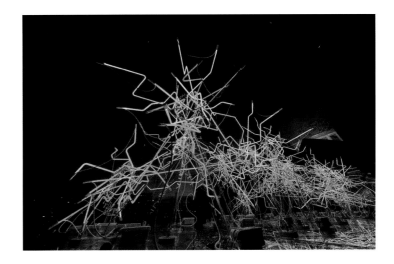

*Neon 206*, 2017
Neon glass and acrylic
264 x 991 x 330 cm
(104 x 390 x 130″)
Groninger Museum,
Groningen, Netherlands,
installed 2018

## SOURCES AND FURTHER READING

**Books:**

*Chihuly over Venice*. Portland Press, Seattle, 1996.

*Chihuly at the Royal Botanic Gardens, Kew*. Portland Press, Seattle, 2005.

*Chihuly Garden Installations*, Portland Press, Seattle, distributed by Abrams, New York, 2011.

*Chihuly: Through the Looking Glass*. Museum of Fine Arts Publications, Boston, 2011.

*Chihuly: New York Botanical Garden*. New York Botanical Garden, New York, DelMonico/Prestel, Munich, 2017.

Opie, Jennifer Hawkins (ed.). *Chihuly at the V&A*. V&A Publications, London in association with Portland Press, Seattle, 2001.

McDonnell, Mark (ed.). *Chihuly on Fire*, Chihuly Workshop, Seattle, 2016.

**Films:**

*Chihuly at the Royal Botanic Gardens, Kew*. Directed by Peter West, produced by Mark McDonnell. Portland Press, Seattle, 2006.

*Chihuly in the Hotshop*. Directed by Peter West, produced by Mark McDonnell. Liner notes by Matthew Kangas. Portland Press, Seattle, 2008.

*Chihuly Outside*. Directed by Peter West, produced by Mark McDonnell. Chihuly Workshop, Seattle, 2012.

**Websites:**

https://www.chihuly.com

https://www.kew.org

## ACKNOWLEDGEMENTS AND CREDITS

**Kew Publishing would like to thank the following for their help in the development and preparation of this book:**

Team Chihuly; Tim Richardson; Nick Thompson, Maria Devaney, Sharon Willoughby, Josephine Maxwell, and the Creative Services team from the Royal Botanic Gardens, Kew.

'Introduction to Dale Chihuly', p18–29, is based on biographies written by Chihuly Studio and Davira S. Taragin (Consulting Curator for the School of Art, Ball State University, Muncie, Indiana, and Lowe Art Museum, University of Miami; Independent Curator).

Tim Richardson is an internationally respected landscape critic. He is a former landscape editor at *Wallpaper*, gardens editor at *Country Life* and founding editor of *New Eden* magazine. He is a contributing author on *Chihuly Garden Installations* (Abrams Books, 2011) and is the author of several books on gardens, including *Great Gardens of America* (Frances Lincoln, 2009), *Avant Gardeners* (Thames and Hudson, 2009), *The Arcadian Friends* (Bantam, 2007), and *Sweets: A History of Temptation* (Bantam, 2002).

**Photography credits:**

© RBG Kew: cover and inside photography Jeff Eden (unless stated below), Ines Stuart-Davidson, p98-99.

© Chihuly Studio: Chuck Taylor, p. 54 (right); Claire Garoutte, p. 39 (left), 44 (right), 60 (left); David Emery, p. 54 (left);  Eduardo Calderon, p. 37 (bottom); Jody Coleman, p. 39 (right); Philip Amdal, p. 40 (left); Ray Charles White, p. 112–13; Roger Schreiber, p. 53 (right); 55; Russell Johnson, p. 116, 117, 118; Scott Mitchell Leen, pp. 6, 12–13, 18, 29, 37 (top right); 45, 46, 47 (right), 48, 49, 50 (right), 51, 52 (left), 58 (right), 60 (right), 61, 62, 63, 66, 82–83, 86-87, 92, 110, 114–15, 119; Shaun Chappell, 50 (left); Teresa Nouri Rishel, p. 36, 37 (top left), 52, 56, 57, 58 (right), 59; Terry Rishel, p. 11, 16, 41, 42, 43, 44 (left), 47 (left), William T. Schuck, p. 38. Additional photos provided by Chihuly Studio: pp. 21, 40 (right), 115 (top).

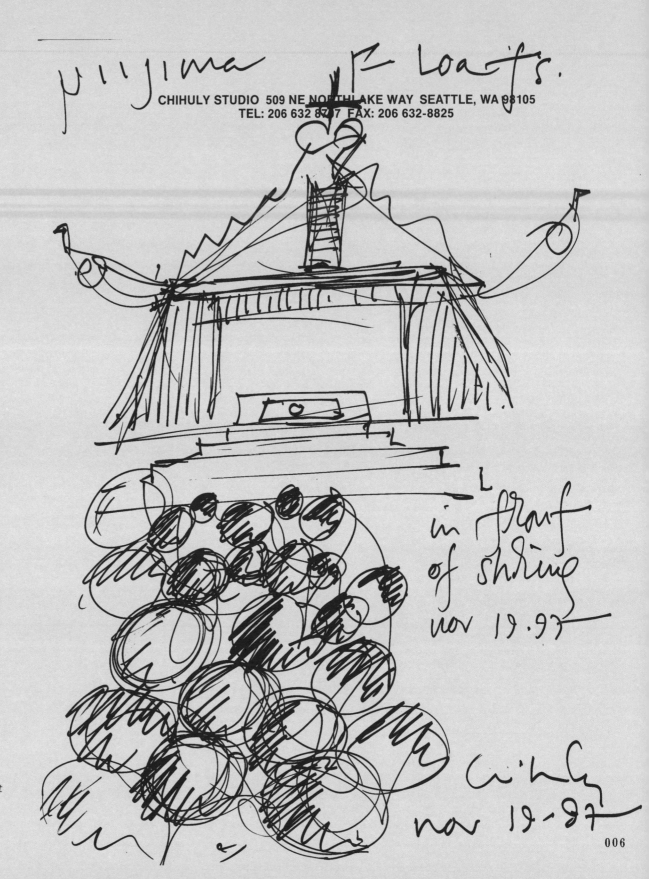

niijima Floats.

CHIHULY STUDIO 509 NE NORTHLAKE WAY SEATTLE, WA 98105
TEL: 206 632 8727 FAX: 206 632-8825

in front
of shrine
nov 19.97

Chihuly
nov 19-97

006

Endpapers:

Fax sketch of *Niijima Float*
Project, Niijima, Japan
1997

Fax sketch of *White
Belugas* for *Chihuly in the
Light of Jerusalem 2000*,
Tower of David Museum,
Jerusalem, 1999